IMAGES
of America

FALL RIVER COUNTY
AND HOT SPRINGS
VIEWS FROM THE PAST

1881–1955

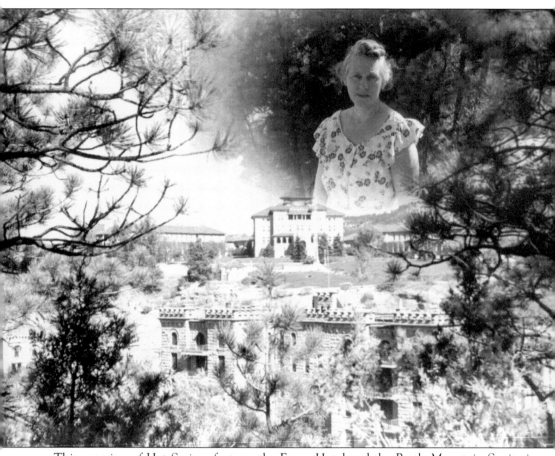

This overview of Hot Springs features the Evans Hotel and the Battle Mountain Sanitarium (now Veteran's Administration Center). The inset is Rhea Smith Roth Meek who was the Hot Springs city librarian in the late 1930s and early 1940s. (Photo courtesy of Fall River County Museum, Hot Springs.)

IMAGES
of America

FALL RIVER COUNTY
AND HOT SPRINGS
VIEWS FROM THE PAST

1881–1955

Peggy Sanders

ARCADIA
PUBLISHING

Published by Arcadia Publishing
Charleston, South Carolina

Printed in the United States of America

Library of Congress Catalog Card Number: 2002106326

For all general information contact Arcadia Publishing at:
Telephone 843-853-2070
Fax 843-853-0044
E-mail sales@arcadiapublishing.com
For customer service and orders:
Toll-Free 1-888-313-2665

Visit us on the Internet at www.arcadiapublishing.com

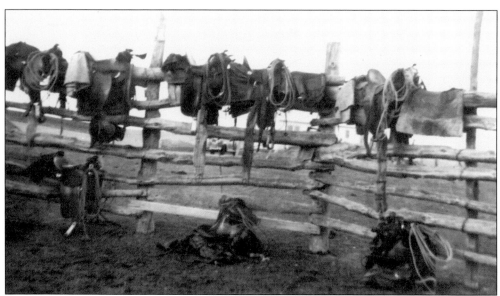

In the early 1940s, these saddles and their cowboys were resting for the night at the Ray and Helen Sides' Ranch east of Smithwick. The isolated location brought in many overnight guests as they were traveling through the rangelands.

CONTENTS

ACKNOWLEDGMENTS

This book would not have been possible without the cooperation of these individuals. Thank you! My husband, Russ, Samantha Gleisten, my editor at Arcadia Publishing, Russell and Betty Wyatt, Harold and Dorothy Wyatt, LeRoy and Rae Wyatt, Carlene Lang, Celeste Lee, Carl and Kari Sanders, Neil Sanders, Cristina Haehnel, Virginia Thompson, Paulene Staben, Caroline Curl, Roy and Jacque Bledsoe, Mick and Edie Jenniges, Mary McDill, Ruth Ronge, Don and Colleen Peck, Leona Brown, Sally and Wayne Hageman, Barb Landers, Bernice Landers, Jebediah Smith Corral of Westerners # 62, Violet Biever, Adeline Frahm, Rose and Joel Rickenbach, Lanoir Pederson, Helen Sides, John and Carol Sides, June and Marv Wilkinson, Gladys Halls, Gene Miller, Jiggs and Lucille Mower, Jean Weldon, Dorothy Gordon, Fall River County Historical Society, Fall River County Museum, Paul Hickok, John Stanley, Sheila Scanson and Gene Eiring at the South Dakota State Veteran's Home, Everett Gillis, Erin Cassity Gates, Lucille Birkholtz, Virginia Lautenslager, Phyllis (Seder) Filler, Reinhold Krein, Floyd Jerdon, Kay Huxford, Florence Huxford, Harold and Shirley Sieg, Delbert Writer, Angostura Irrigation District, Colleen Kirby with the E.Y. Berry Library at Black Hills State University, and the many people who helped with photo identification.

INTRODUCTION

In 1881, after five years of marriage, my great grandparents, Ira and Harriet (Hattie) Tillotson decided to join the westward movement to the Black Hills from Storey County, Iowa. Although they did not know where their journey would ultimately take them, they set out with their two children, Claude and Grace, and a neighbor boy named Johnnie Virtue. They traveled to Nevada, Iowa and chartered an immigrant car for themselves, their household goods, and their livestock. Their horses, two fine teams, and a saddle horse, were made secure in one end of the car. The wagons were taken apart and placed to form a partial partition between the livestock and living quarters. Next came the household goods—all of this in one freight train car.

The first leg of the journey took them to Mankato, Minnesota. When they arrived Ira decided it would be better if he continued on in the freight car and his family should layover a few days and then take a passenger train to Pierre. In a short while, the family was reunited in Pierre, Dakota Territory. They restocked their supplies and the next day crossed the wide Missouri on a ferry. After reassembling the wagons and adding the canvas covers to the bows of the wagons, the Tillotsons and their two prairie schooners were ready. At last they were pioneers on the Pierre-Deadwood Trail! Before they could cross the next river in their path, the Cheyenne, rains began and they had to wait several weeks before it was safe to cross. Each day brought new travelers from the East. One of the men who arrived in camp was Col. W.J. Thornby and his new bride from New York. Thornby was well known in the Black Hills and later had much influence in settling Hot Springs. Once the Tillotsons arrived in Deadwood, they looked it over and decided to venture further. They went on to Hill City and stayed there for a few months. Ira and Hattie had heard about the foothills on the southern edge of the Black Hills and went to investigate for themselves. They found a place near the Cheyenne River and on March 10, 1881, Ira filed on a 160 acre homestead near Cascade, south of Hot Springs. That land is the oldest Century Farm in Fall River County, so designated because it is still a working farm owned by direct descendants of the Tillotson family, Harold and Dorothy Wyatt. They still live in the Tillotson house which was built in 1906. Thus begins this photo history book.

Homes of the era, from soddies to mansions, are shown to remind readers how easy our lives are now. Where possible, for houses that remain and are wonderfully preserved, the addresses are given in this book. As you drive by these homes, you can compare then and now. When

one looks at a photo of a tar-paper shack, it is not possible to imagine, in this day and age, how anyone could have survived several winters in such housing. But many folks did, they are described as "hearty pioneers," as were those who traveled by wagon, on horseback, or even on foot to arrive at their destinations.

This book highlights the every day activities of people from throughout the county—the ones who made Fall River County what it is. The day to day workers who kept everything going, the men at the lumberyard, the pioneers, homesteaders, cowboys, farmers, homemakers, quarry workers, service station mechanics, blacksmiths, firemen, and builders of Angostura Dam, are pictured among the vintage images represented.

The early settlers on the Angostura Irrigation Project were adventurers in their own right. The land was bought by the government and then resold to the individual farmers. The Project was surveyed and leveled into parcels of land called units. The applicants for the units had to meet certain criteria in order to apply to purchase a farm. The initial requirements were to be a U.S. citizen in good health and have an agricultural background. Applicants had to have at least $3,000 in cash or credit and be interested in living on the unit as a permanent residence. Veterans of World War II and those who had lived on the land before the government bought it for the Project, had preference. A Family Selection Committee screened the applicants and made the final decisions as to who would be offered units. A lottery was held among the veteran applicants to determine unit assignments.

In Fall River County—especially in Hot Springs—much is known about Fred Evans and the other founders, movers, and shakers of the town. But what about the common folk? It is to them that this book is dedicated.

Many faces and places will be known to readers and it is hoped that this recognition will elicit smiles and happy memories.

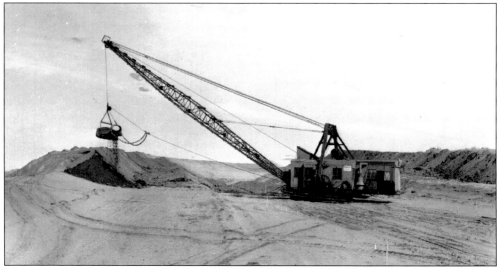

The Monighan, a huge, diesel walking dragline was one of the machines used by the Utah Construction Company to excavate land for the Angostura Irrigation Project. A tracked vehicle, it had two sets of independently articulated tracks. One set would move then the other would crawl. It traveled one-half mile per hour.

One

FRIENDS AND NEIGHBORS

Ira and Hattie Tillotson, filed on a homestead of 160 acres on March 10, 1881. They named the place Glencoe Ranch and it is located near Cascade, south of Hot Springs, in Dakota Territory.

Mrs. A.J. (Rose) Landers and her children, Agnes and Gene, prepared to go on a venture.

Everett Gillis, Cascade, broke horses for others as a means of income.

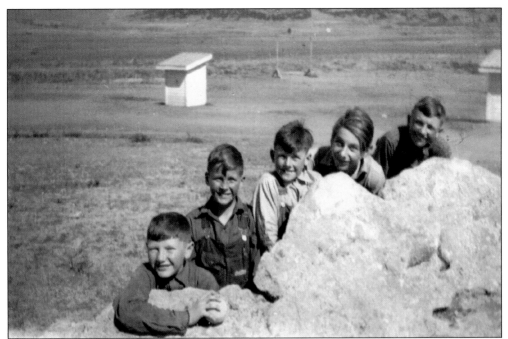

The Coffee Flat School, just south of Cascade and the Cheyenne River, hosted many fun-filled moments with these boys, Blaine Halls, Kenny Pierce, Harold Wyatt, Ralph Fitzner, and Russell Wyatt. The boys' and girls' outhouses were used as bases for baseball games during recess.

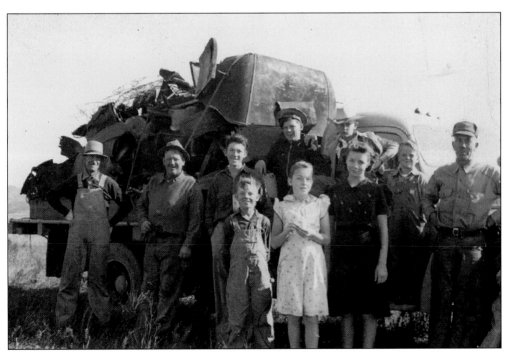

During World War II, everyone got into the spirit of helping. Coffee Flat School held a scrap metal drive to further the war effort.

Arthur Ferris was the night man at the South Dakota State Soldiers' Home in Hot Springs for many years. He lived on site above the craft shop. (Photo courtesy South Dakota State Soldier's Home.)

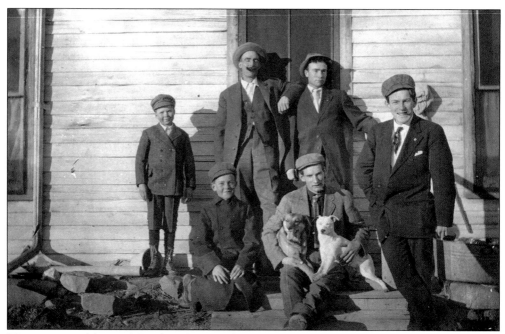

These men and boys of Smithwick seemed to enjoy their lot in life. Standing on the left is Roland (Slim) Larson. Seated at left is Dan Larson. The others are unidentified.

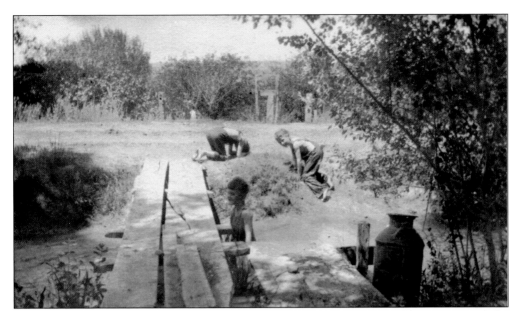

An irrigation ditch was a treat for these boys in the summer. Herman Mahler constructed the ditch and others downstream obtained water rights. The water brought forth tremendous crops for the farmers and ranchers.

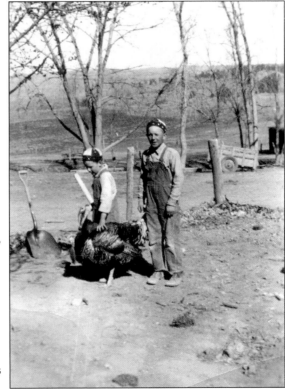

Oscar the Turkey along with his friends, Harold and Russell Wyatt, grew up together on the Wyatt farm near Cascade, South Dakota. Oscar arrived in a Pettyjohn Cereal box at the farm in May of 1929, when Harry was six months old. Oscar tolerated the rest of the family, but he was Harold's true friend. The turkey walked along slowly so Harold could put his hand on Oscar's back as they walked together.

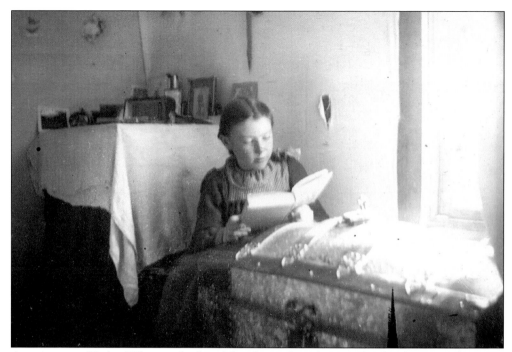

At age nine, Gladys Tillotson displayed her love of reading in the family's stone house at Glencoe Ranch.

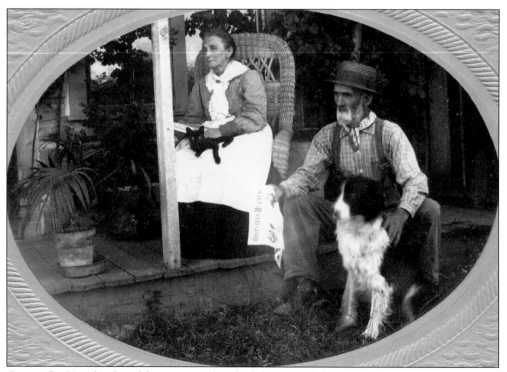

George R. Hoagland and his unnamed wife did some of their reading on the front porch. George has a copy of the *Christian Science Monitor* in his hand.

Bessie Thomas, who learned to work at a young age, was very earnest as she did her chores.

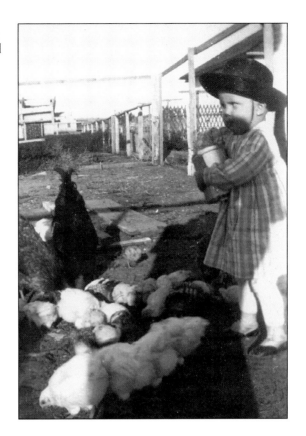

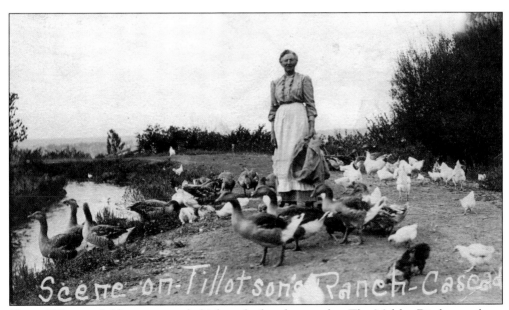

Hattie Tillotson fed her geese and chickens by hand every day. The Mahler Ditch was also a drinking source for the animals.

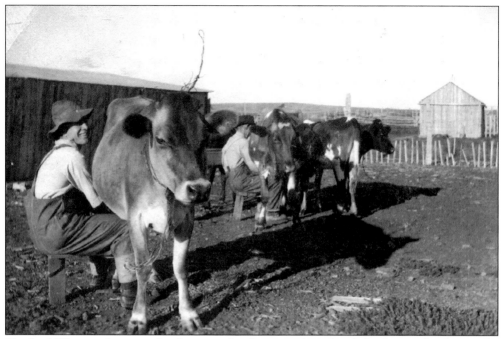

Hartland Wyatt is shown in the foreground as he went about his daily chores of milking. The cattle were tame and needed no stanchions as they stood in the barnyard. The second man is not identified.

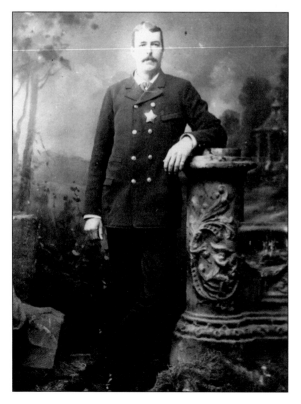

Charles E. Roe was 31 years old and chief of police in Hot Springs in this photo dated 1891. Before that, he worked at the WG, TAN, Bar T, and TOT ranches. After his retirement from police work, Roe purchased his own ranch southwest of Cascade in 1898. He lived there until 1936 when he moved back to Hot Springs. (Photo courtesy of Fall River County Museum, Hot Springs.)

Charles (Bus), Gladys, and Blaine Halls showed what fun could be had with a wagon and a goat.

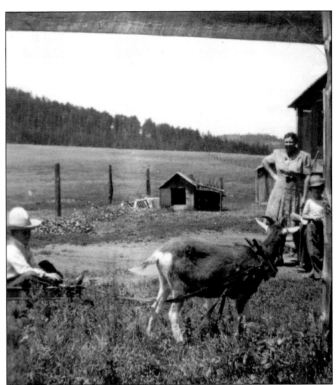

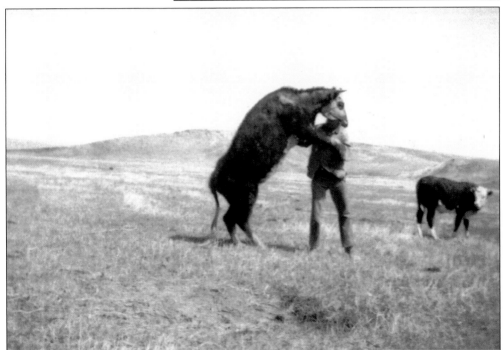

Bert Thompson, an Oral area rancher, taught this cow to jump on his shoulder when she was just a calf. She never forgot the trick. Her own calf seemed to be wondering if he had to do that also.

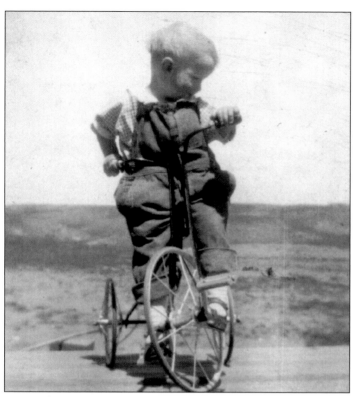

Harold Sieg was not quite four years old when he was riding this tricycle in July of 1929.

Shirley, Virginia Irene, and Wesley Kain are pictured at Grandma Kain's homestead shack on Hay Canyon in about 1928. The white coat was a fake fur called plush.

The Victory Bar in Edgemont employed Maurice Egen as a bartender. George Grable was is man on the bar stool.

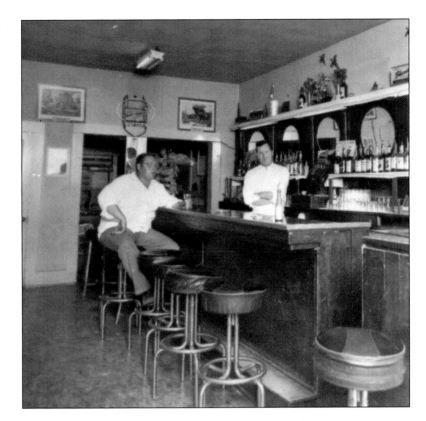

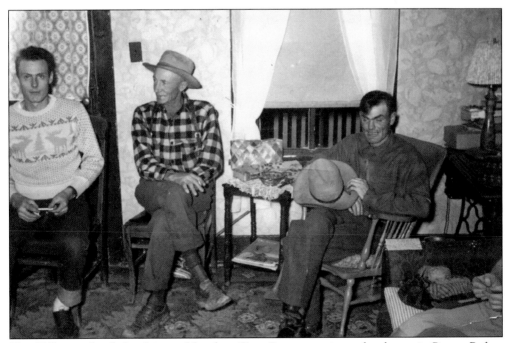

Tiny Tillotson, his father Lin, and brother, Otto Gene, are pictured at home in Provo. Before Lin died, he pre-paid for a party to be held after his funeral at the Victory Bar.

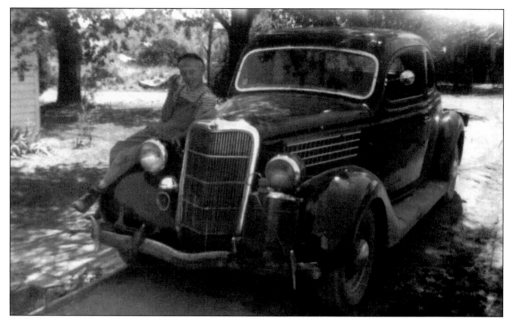

In August of 1946, Harold Sieg owned a '35 Ford that had a damaged rear gas tank. He improvised and installed a 5-gallon gas can with the necessary tubing and hardware to run the car. The contraption was on the front bumper. His brother, Ralph, was sitting on the fender when the photo was taken.

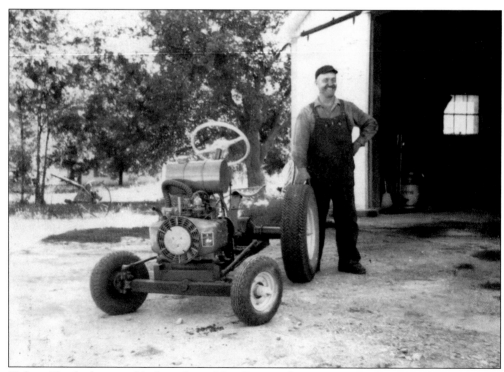

Hobart Huxford was a blacksmith in Hot Springs for many years. He was also a creative inventor and is shown with a garden tractor that he built from scratch.

"Entrepreneur" could have been L.L. (Lyston Lloyd) Wyatt's middle name. He sold radios, Delco batteries, farm produce, and many other products over the years.

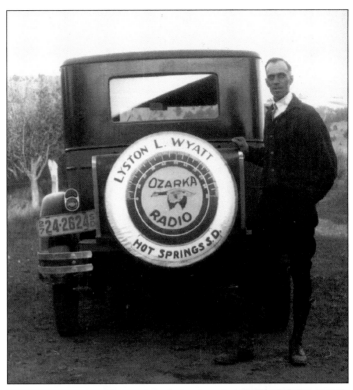

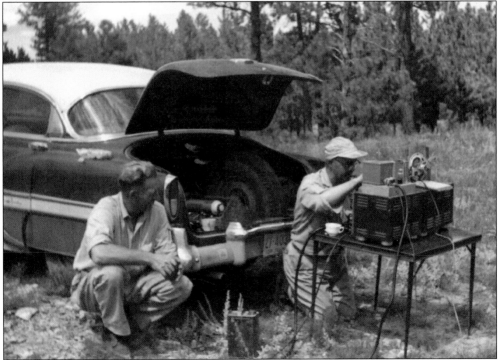

Ham radios have been important in communications over the years. An unidentified man accompanied Hobart Huxford to a rural location to try out such a radio.

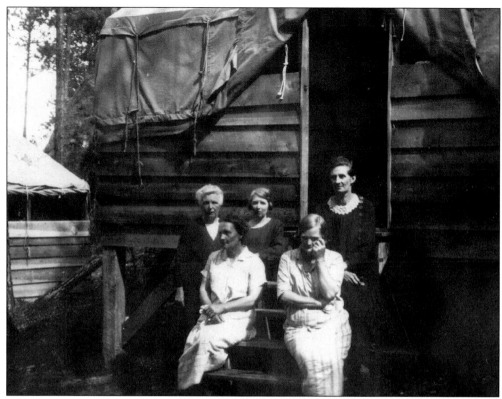

Fall River County Extension Agents did their best to educate men and women in the necessities of life. In 1926, several mothers from the Minnekahta community attended Mother's Camp.

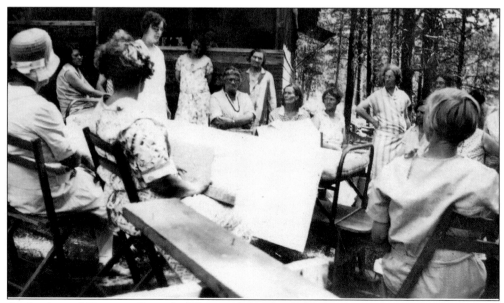

At the Annual Vacation Camp for Women, formerly Mother's Camp, at Hisega, South Dakota, these women had an extension lesson in care for the sick in 1930. Home Demonstrations began in the county about 1917. The first organized extension clubs were canning clubs.

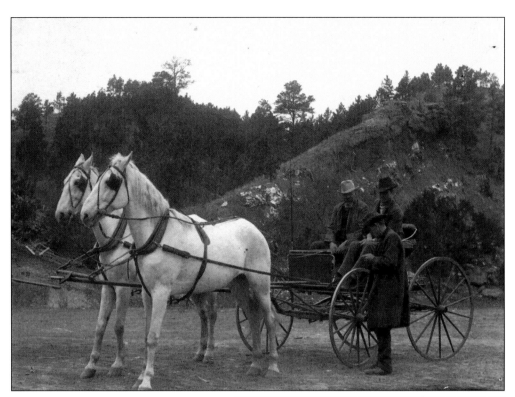

A bearded Fred T. Evans is shown here with his white horse team, Frank and Charley, in 1890. He was a mover and shaker in the founding of Hot Springs. He also owned the Northwestern Transportation Company, a freight hauling outfit that mostly traveled between Fort Pierre and Deadwood, among his other ventures. (Photo courtesy of Fall River County Museum.)

New technology also brought new difficulties. Here, Ed Hageman of Oral changes a flat tire.

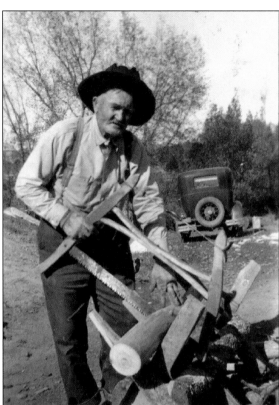

Ira Tillotson knew well the meaning of the phrase, "He who cuts his own wood, is twice warmed."

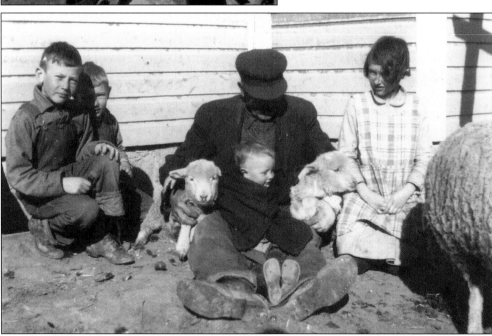

Even while working, grandparents took time to enjoy their grandchildren. Bus and Blaine Halls, with their sisters, Fern and Barbara, are pictured here with the lambs and Grandpa Ira Tillotson.

The Tillotson girls of Glencoe Ranch were all grown up when they were Grace Stewart, Fern Wyatt, and Gladys Halls.

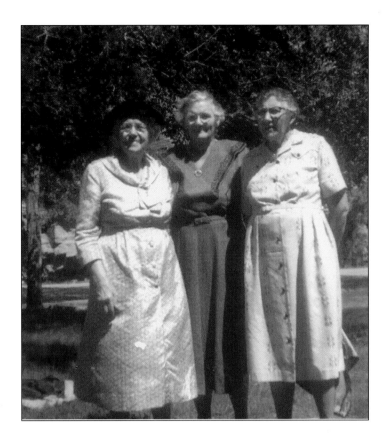

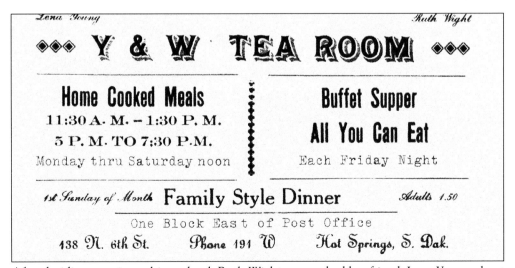

Lena Young *Ruth Wight*

◆◆◆ Y & W TEA ROOM ◆◆◆

Home Cooked Meals

11:30 A. M. – 1:30 P. M.

5 P. M. TO 7:30 P.M.

Monday thru Saturday noon

Buffet Supper

All You Can Eat

Each Friday Night

1st Sunday of Month **Family Style Dinner** *Adults 1.50*

One Block East of Post Office

138 N. 6th St. *Phone* 191 W *Hot Springs, S. Dak.*

After deciding to quit teaching school, Ruth Wight approached her friend, Lena Young, about starting a small restaurant. They decided on the Y (as in Young) and W (as in Wight) Tea Room which they ran together for several years.

July 19, 1936 was the first day of airmail service from the Hot Springs Post Office. Postal workers were Nelson Northrup, John Hagen, John Huebnor, Glenn Crofts, Dave Batchelor, Bill Huebnor, Everett Gillis, Bill Dumke, Chuck McClenon, Elgin Walker, Bishop Cole, and Art Hagen.

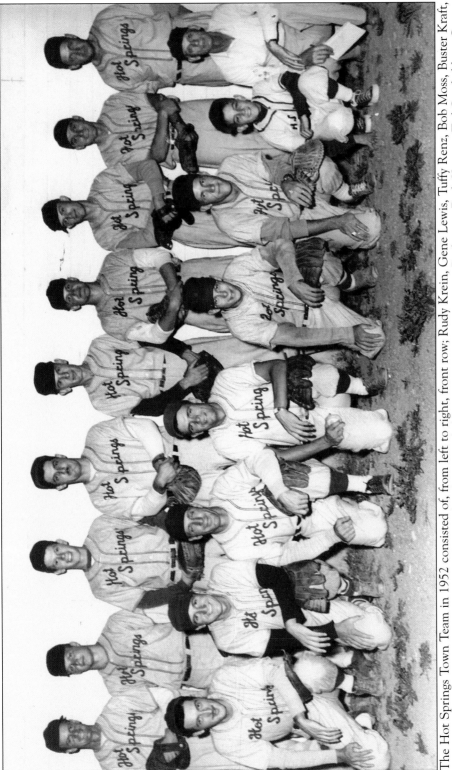

The Hot Springs Town Team in 1952 consisted of, from left to right, front row; Rudy Krein, Gene Lewis, Tuffy Renz, Bob Moss, Buster Kraft, Bud Jenniges, Val Jenniges was the bat boy, and Selmer Smebakken was assistant manager. Back row; Dick Kienitz, Ted Smebakken, Sonny Kaiser, Reinhold Krein, Red Kaiser, Clay Smebakken, Clint Webber, ? McCloskey, and manager Norm Jenninges.

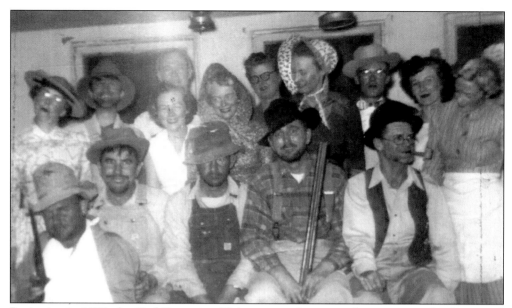

Beginning in 1954, the Oral Extension Club sponsored an annual community play for several years. One was *Tumblin' Creek* in which these actors appeared. Pictured from left to right are Curtis Hageman, Clem Russell, Vic Wilhelm, Everett Wilson, Wilbur Emick, Inez Dulin, Oleta Wyatt, Elsie Renz, Joan Oellrichs, Virginia Thompson, 2 unidentified men, Elvera Varvel, Jiggs Mower, and Myrt Wilson.

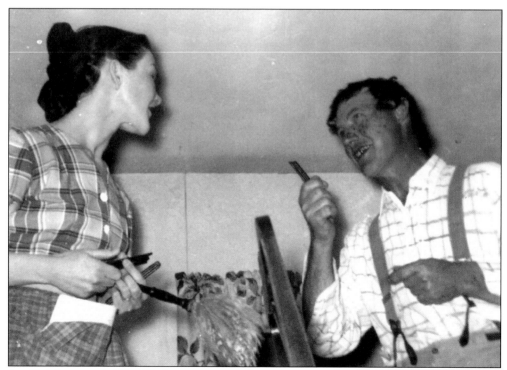

Lucille Mower and Alfred Seder entertained the audience in this Oral play. Funds raised from these plays went to assist 4-H members go to the state conference and to aid the Red Cross.

Myrt Wilson and Jiggs Mower hammed it up.

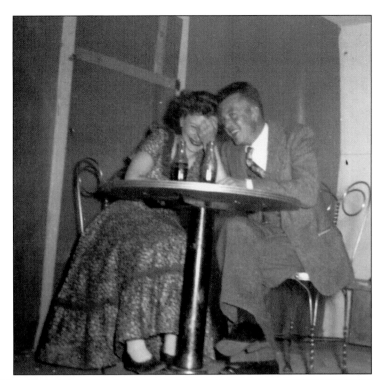

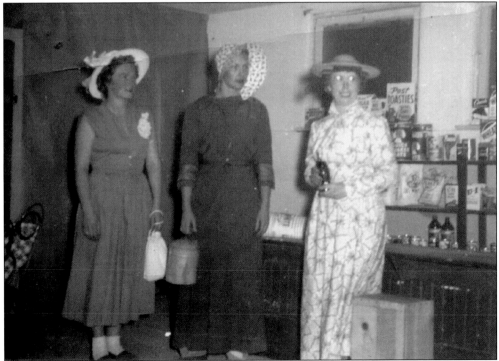

Oleta Wyatt, Joan Oellrichs, and Inez Dulin contributed their talents. The plays were held downstairs in the Oral Methodist Church, as were most group functions because it was the largest building in town. The curtain that was used between acts still hangs in the basement.

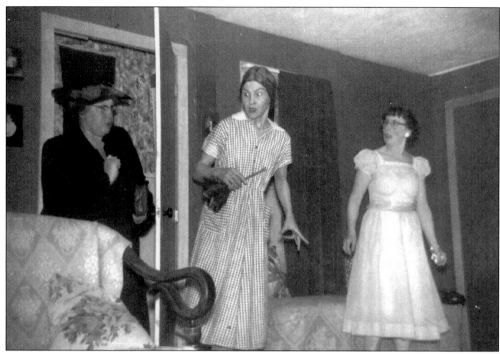

Pauline Hageman, Lucille Mower, and Inez Dulin kept the crowd roaring with laughter.

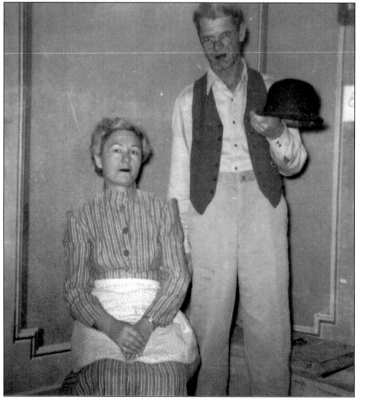

Virginia Thompson was dubbed Simplicity McPheeters and Wilbur Emick was known as Silas in "Silas Smidge from Turnip Ridge." Simplicity's character called for a woman "comical of speech and manner, warm-hearted and human to a degree." Virginia's maiden name and her married name were both Thompson.

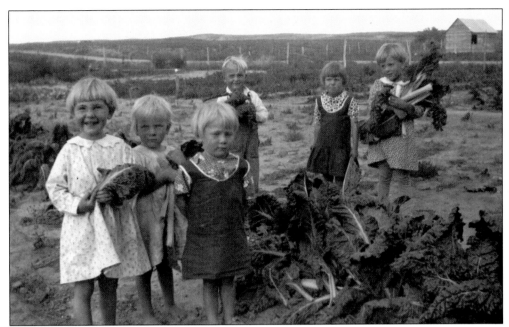

Darlene, Rose Mary, and Wilma Peters were harvesting Swiss chard from the family garden. Their helpers were Gene Landers, Mary Lou Peters, and Agnes Landers.

Lin Seder and Pat Gilkey had a little melon at the Alfred Seder farm, east of Oral, in 1950. Notice the Skelgas bottles which supplied propane into the house. There was no electricity until after 1955 when REA came to the Angostura Irrigation Project.

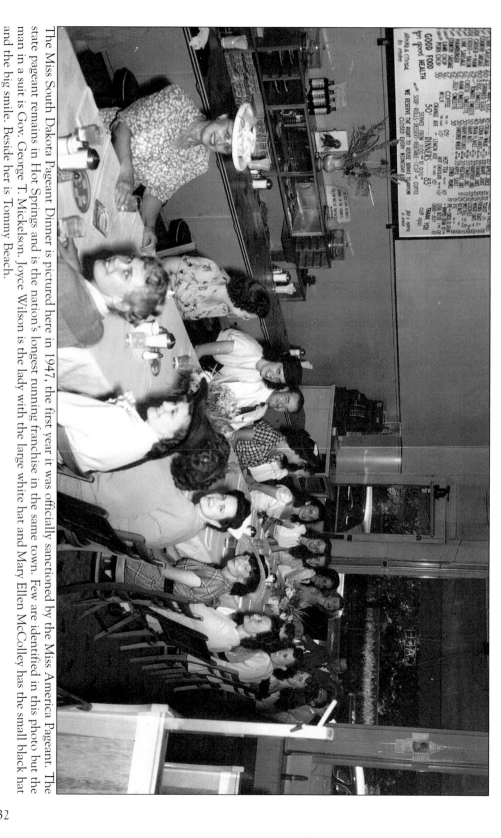

The Miss South Dakota Pageant Dinner is pictured here in 1947, the first year it was officially sanctioned by the Miss America Pageant. The state pageant remains in Hot Springs and is the nation's longest running franchise in the same town. Few are identified in this photo but the man in a suit is Gov. George T. Mickelson. Joyce Wilson is the lady with the large white hat and Mary Ellen McColley has the small black hat and the big smile. Beside her is Tommy Beach.

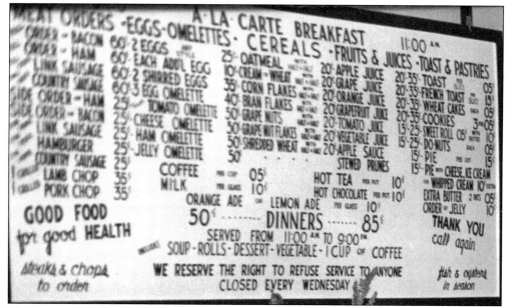

Here is the menu board from the same cafe in 1947.

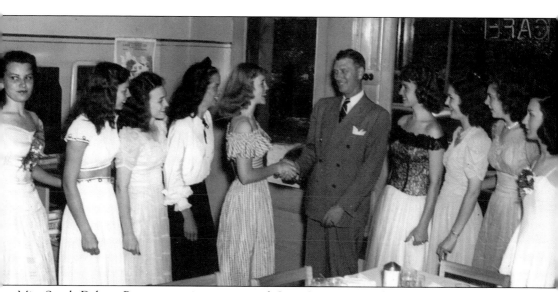

Miss South Dakota Pageant contestants greeted Gov. George T. Mickelson in 1947. Shaking hands with the governor was Marilyn Andersen, daughter of George and Martha Andersen of Hot Springs.

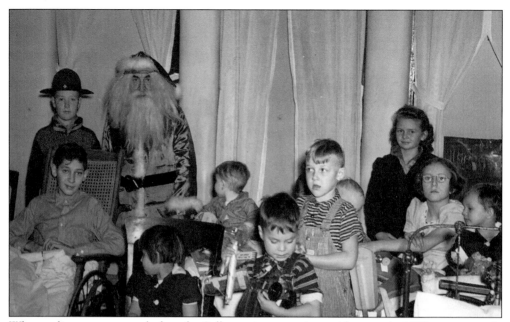

When polio was rampant, before the Salk vaccine came into wide usage in 1955, many people young and old were affected with the virus. Hot Springs had the West River Crippled Children's Hospital. Mr. Klock was the area Santa Claus and he, along with the Boy Scouts and many others, visited the children at the hospital to help them pass the time. (Photo courtesy of Fall River County Museum, Hot Springs.)

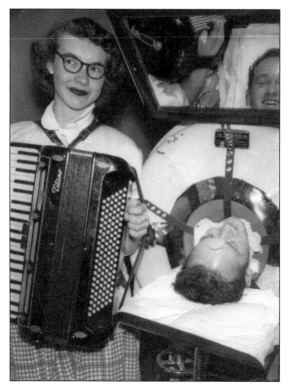

Phyllis (Seder) Filler played her accordion for Lyle Wells, a patient, who was in an iron lung. The polio virus partially or completely paralyzed victims. If the breathing was affected the patient was aided by being placed in an iron lung which enabled the patient to breathe. Notice that only the patient's head was exposed and the rest of his body was in the iron lung.

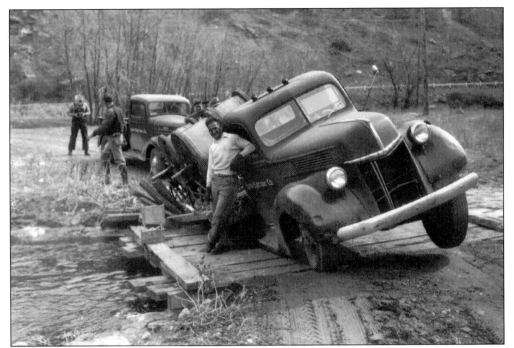

A broken plank from an overloaded '41 Ford pickup caused a slow down in this day's activities for driver Glen Harley.

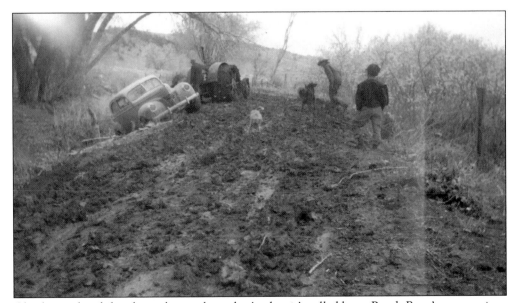

Oh, the mud and the clay soil—gumbo—that's what it's called here. Butch Renz' car went into the ditch and Rudy Lulf pulled it out with his tractor.

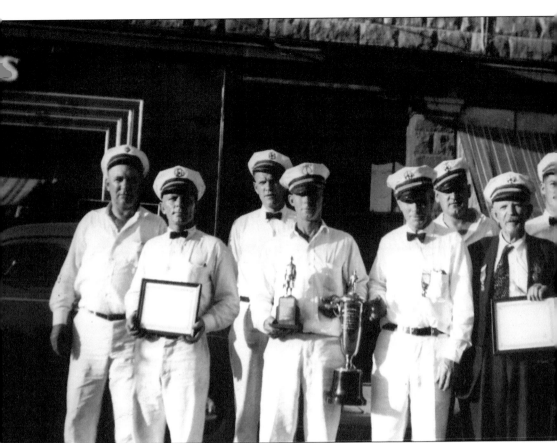

Like many towns in South Dakota, the Hot Springs Fire Department was volunteer, yet trained and professional. For several years the men competed in state fire department tournaments and sometimes brought home the championship. Members included George Kruger, Carl Palmgren, Vic Engelbert, Joe Shook, Clarence (Red) Hall, Bill Engelbert, John Mueller, and Reinhold Krein.

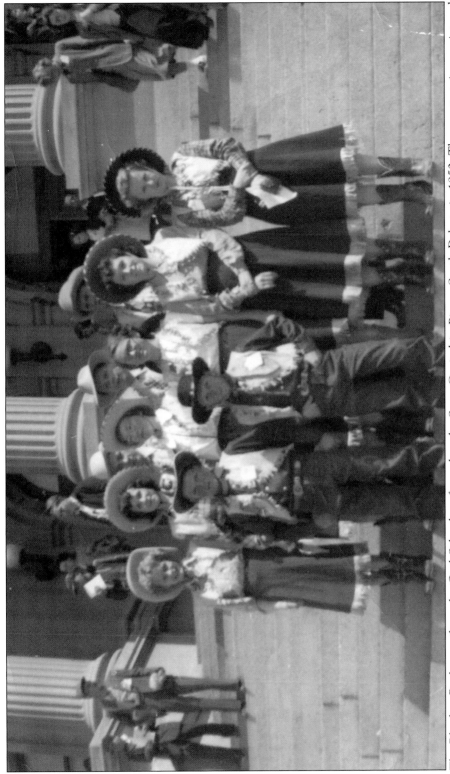

The Rhythm Buckaroos from the Oral School performed at the State Capitol in Pierre, South Dakota in 1950. These entertainers, pictured from left to right, front to back, were Harley Emick, Duane Dulin, Shurlene Fleming, Joyce Cassity, Phyllis Seder, Merrilee Emick, Bev Dulin, ? Graves, Bryce Fleming, Jerry Cassity, and Darrel Renz.

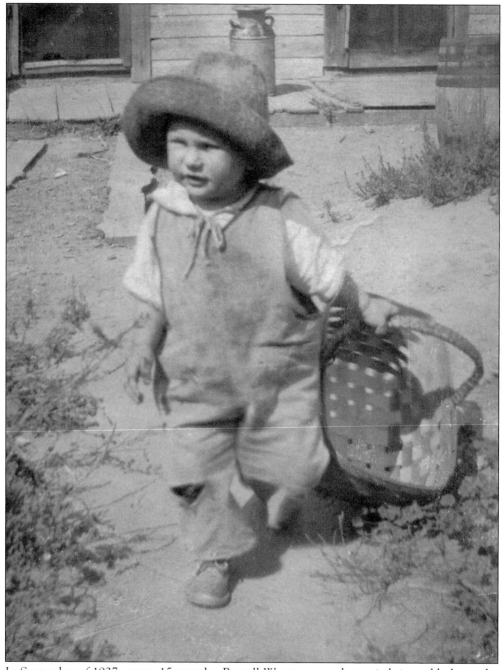

In September of 1927, at age 15 months, Russell Wyatt was ready to pitch in and help on the family farm near Cascade, South Dakota.

Two

TOWNS AND COUNTRY

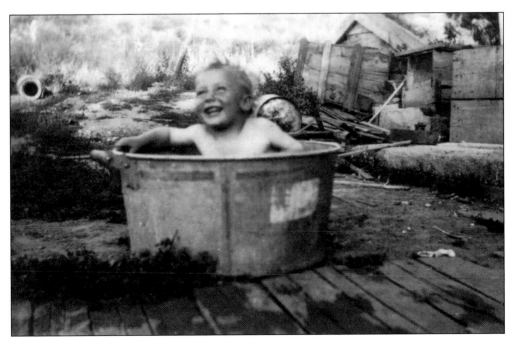

Bus Halls proved that not all little boys hated baths. Before running water was in homes, this is how baths were taken, and many times they were outdoors.

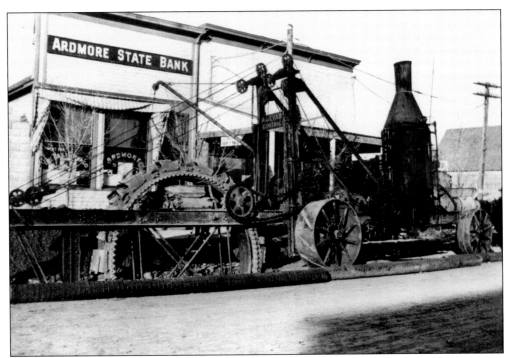

The Ardmore State Bank was almost overshadowed by the machine that installed the pipe. (Photo courtesy of Fall River County Museum, Hot Springs.)

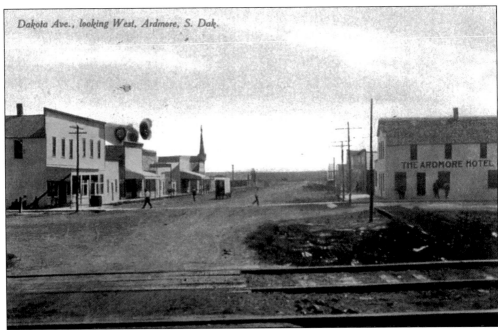

According to this postcard, the Ardmore Hotel was one of the prominent features in downtown Ardmore. It was mailed to Miss Julia Hunter from Louise Meier on February 1, 1914. In the 1920s, there were 350 residents and the U.S. Government Experimental Farm Field Station was located near Ardmore.

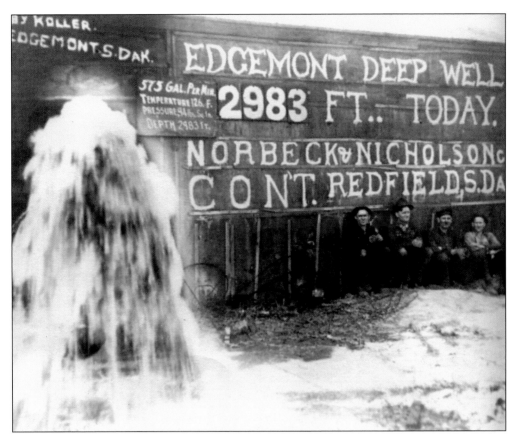

Edgemont was always trying to find water. On the night this artesian well was struck, the fire bell rang so people could get up and see the sight. This 2,983-foot well was 126 degrees when it hit the surface. It was capped and re-directed to where it could be used. The well yielded 575 gallons per minute.

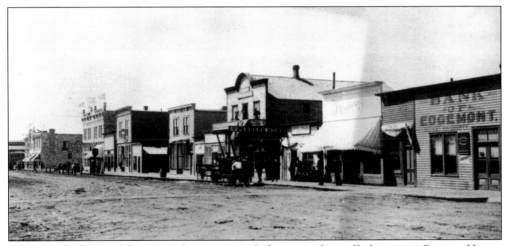

Edgemont had several downtown businesses including a woolen mill, drug store, Parmers Home, Midway Saloon, and the Bank of Edgemont which was the oldest bank in the county.

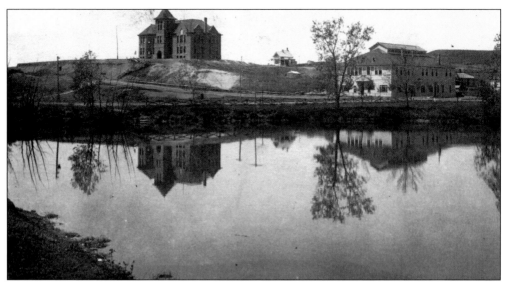

The Edgemont School House and Edgemont Lake were captured in this reflective photo.

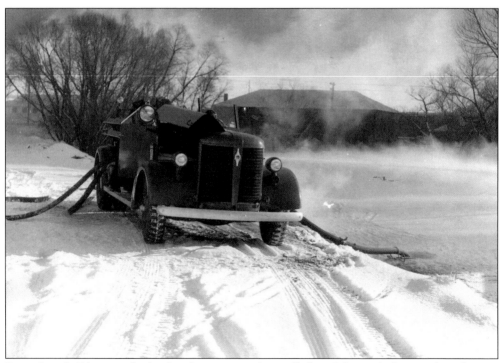

Even though Edgemont had a fire department, they called on Igloo to help out when disaster struck. This incident took place during the winter when the Edgemont Lake was frozen, so first the ice had to be broken. It almost turned into a juggling act as the pumper worked. The water sometimes had to be pumped in reverse, back into the lake, to keep the hoses from freezing.

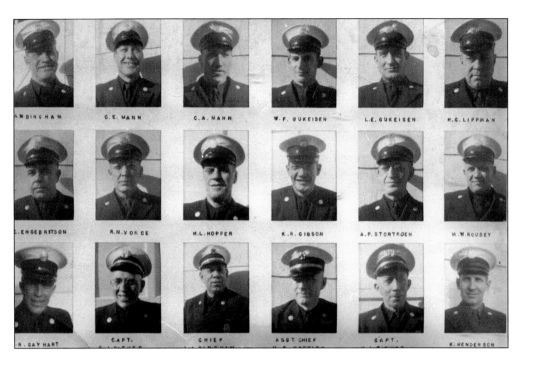

Pictured here is the Igloo Fire Department.

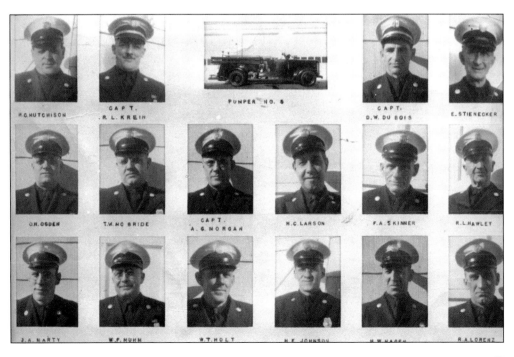

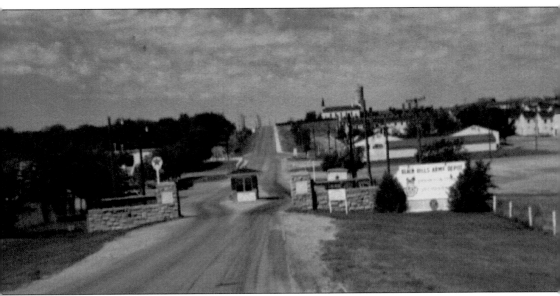

In 1942, on approximately 21,000 acres of land 2 miles from Provo, South Dakota, the eight-month long construction phase began on the Black Hills Ordnance Depot (BHOD). Since it was a military installation, it was a secure, gated facility. This was the main gate.

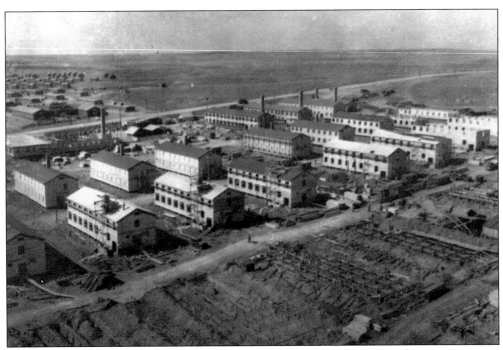

The Army built military housing, a commissary, dispensary, bowling alley, theatre, swimming pool, airport, golf course, a school complete with a track and football field, and all of the other amenities of a military post.

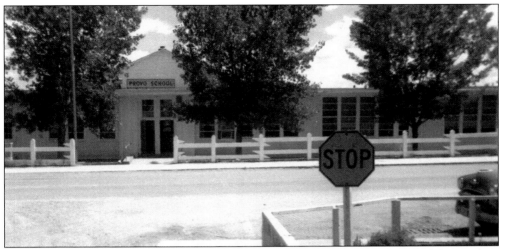

Although the school was located on post, it was called the Provo School, home of the Rattlers. It was open to the students in the areas surrounding the BHOD as well as the children of BHOD personnel.

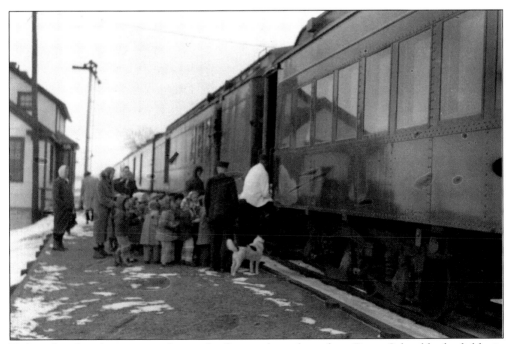

To broaden their horizons, each year the first grade students from Provo School had a field trip on the train from Provo to Edgemont. Busses brought them back to the school after the trip.

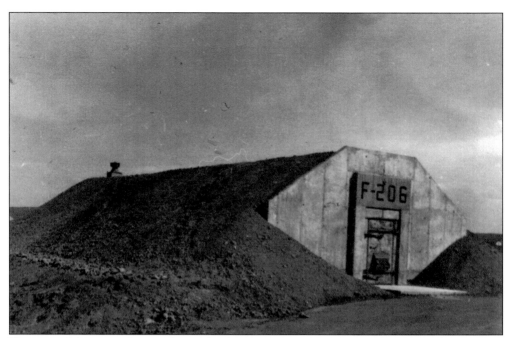

The name Igloo came from ordnance bunkers, or ammunition storage buildings, like this one. Just over 800 of them were built of reinforced concrete covered with earth. The way they were laid out on 9 blocks of land made them look like a city of igloos.

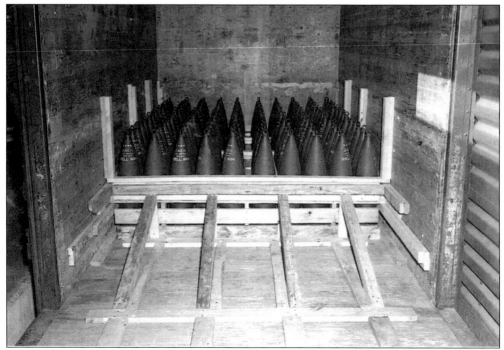

The primary mission of the BHOD was to serve as a reserve depot for the receipt, storage, and issue of ammunition as well as general supply items such as repair parts, supplies, tools, and equipment. Ammunition was also tested at the depot.

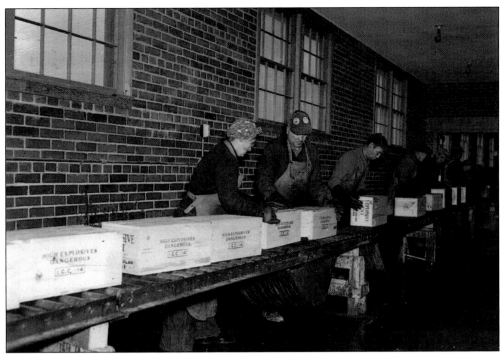

The ordnance was transferred by train cars, and from January to March of 1945, a total of 3,184 train carloads were handled, in shipping and receiving. Many civilian personnel were employed on the depot in various capacities.

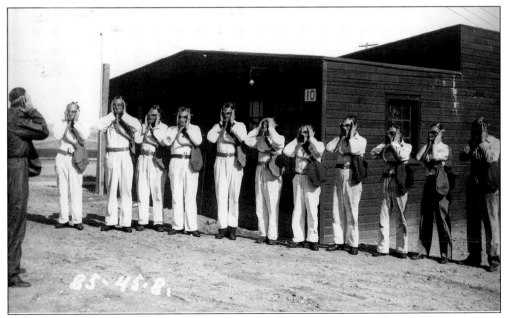

The depot was first built during World War II and Chemical Corps toxic ammunition was part of the inventory. Gas mask training was a necessary part of the routine during the years the facility was active. It officially closed on June 30, 1967, but the igloos are still there and can be seen for miles.

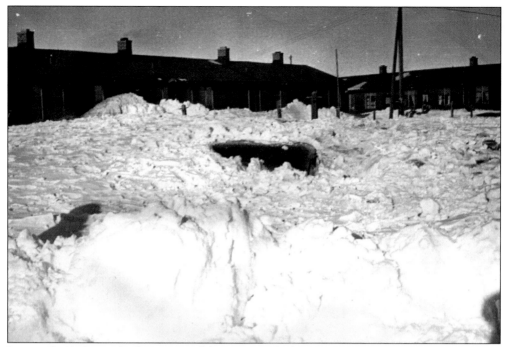

January 2, 1949 was the beginning of the renowned Blizzard of '49 which was actually a series of severe snow storms that raged on and off until February 22nd. Here, the Igloo housing area typifies what many yards and farmsteads looked like.

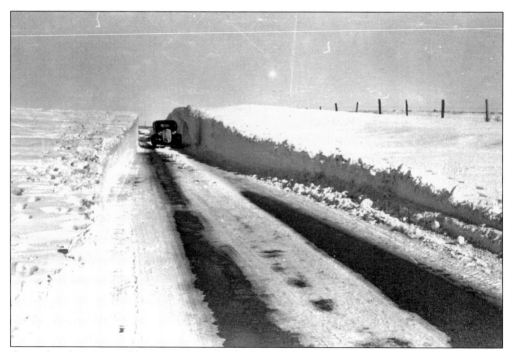

Once the plows were able to get through, the height of the drifts was quite a sight. This is the road between Igloo and Edgemont.

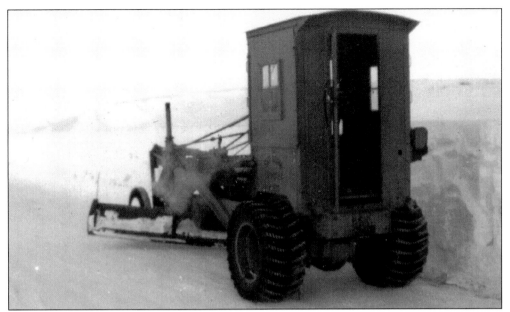

Barney Curl of Edgemont drove this small road grader after the blizzard, attempting to move the snow and clear roads.

Tens of thousands of sheep and cattle perished in the blizzard. The sheep in this photo suffocated under the snowdrifts. Farmers and ranchers lived through an excruciating time as they knew their animals were dying and they could not help them.

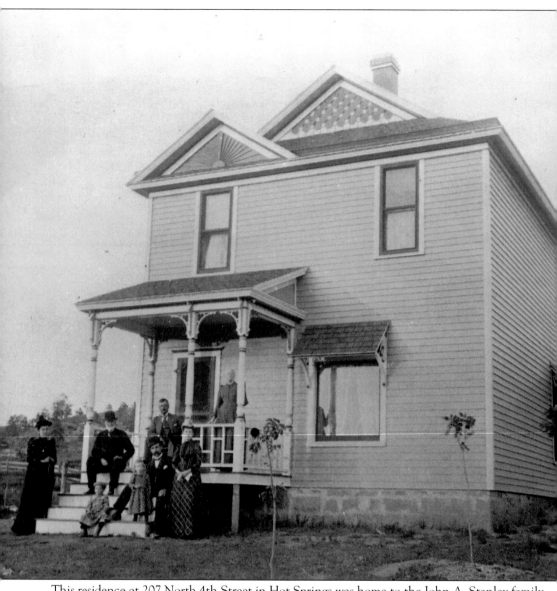

This residence at 207 North 4th Street in Hot Springs was home to the John A. Stanley family from 1892 until 1915. The street was then called Park Avenue.

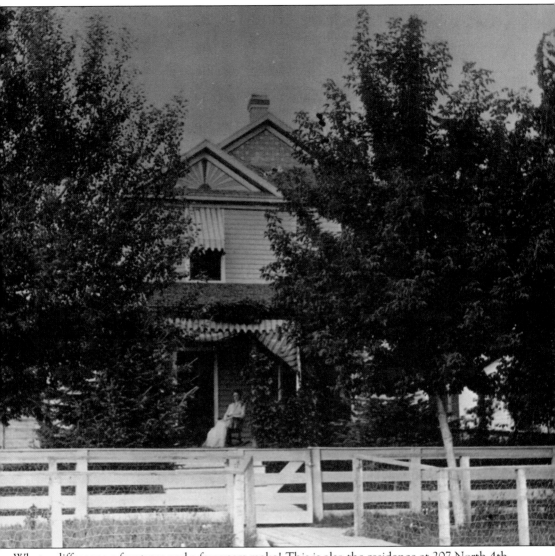

What a difference a few trees and a few years make! This is also the residence at 207 North 4th Street in Hot Springs. (Photo courtesy of Fall River County Museum, Hot Springs.)

The Sisters Hospital, formally named Our Lady of Lourdes, was built in Hot Springs in 1901. An addition was constructed in 1906 from sandstone brought in from Cascade Springs after the Health Sanitarium located there was torn down. The Sisters Hospital was also a nursing school from which 37 nurses graduated between 1908 and 1938. (Photo courtesy of Fall River County Museum, Hot Springs.)

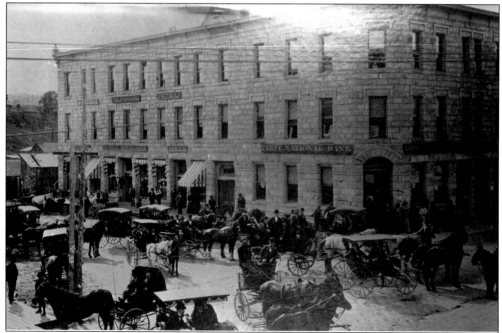

The Fargo and Dickover Block, built in 1890, burned on February 28, 1919. The Plaza Hotel, First National Bank, Masonic Hall, and J.W. Fargo and Company (general merchandise and hardware) were located in the building. At the time of this photo, county offices were in the basement of the building. (Photo courtesy of Fall River County Museum, Hot Springs.)

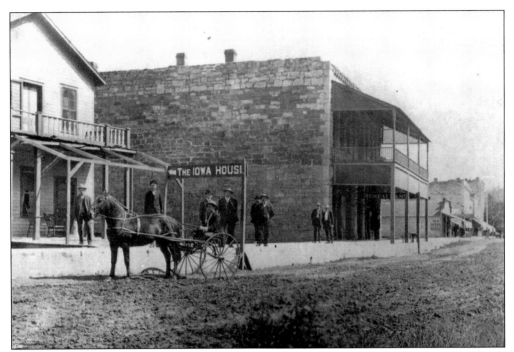

The Iowa House was located between the Gibson House (also called the Flat Iron Building), located at 745 North River Street, and the Wesch-Oak Building, located at 717 North River Street in Hot Springs. It has been an empty lot for several years. Roland (Slim) Larson is standing near the sign, beyond the hindquarters of the horse.

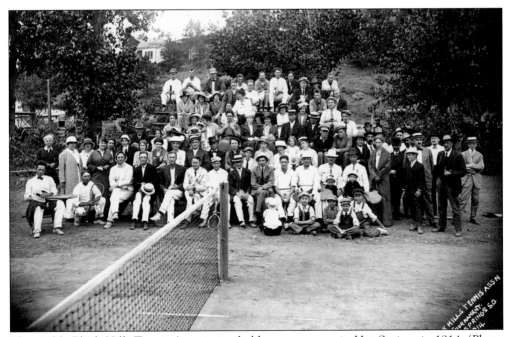

The sizable Black Hills Tennis Association held a tournament in Hot Springs in 1914. (Photo courtesy of Fall River County Museum, Hot Springs.)

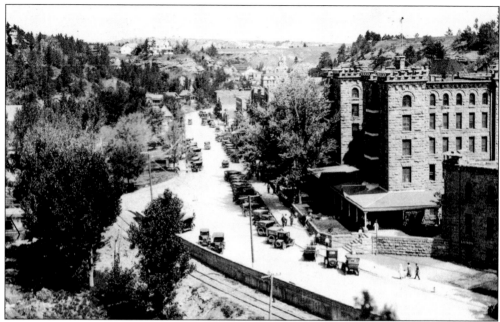

Hot Springs' River Street accommodated diagonal parking in front of the Evans Hotel in the early days when the cars easily fit and did not obstruct traffic. The photo was taken in about 1920.

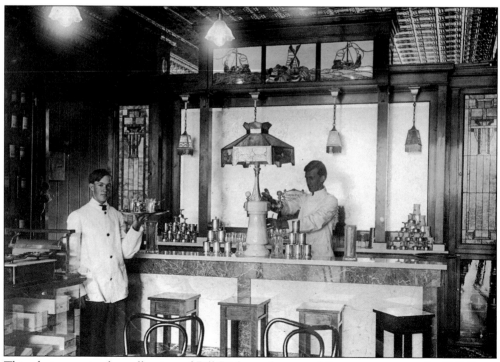

This photo was in the collection of Bill Richer, who served for many years as the Fall River County Clerk of Courts. The location is unknown but it may have been in the Evans Hotel. Ben Richer is pictured on the left and Bill Huebner is behind the bar. (Photo courtesy of Fall River County Museum, Hot Springs.)

Canape Lorenzo

Consomme, aux Flagelettes

Chicken with Okra

Young Onions Stuffed Olives

Dressed Lettuce Table Radishes

Dill Pickles

Broiled Columbia River Salmon
Potatoes, Monte Carlo

Green Lobster Newberg, in Cases

Boiled Calf's Tongue and Spinach

Roast Prime Rib of Beef, al'Essence

Roast Lamb with Mint Sauce

Roast Spring Duck, Walnut Dressing
(Russian Marmalade)

Braised Sweetbreads, Mont Glas

Mashed Potatoes New Potatoes in Cream

New Wax Beans New Peas

Broiled Fresh Mushrooms
(Under Glass Cover)

Apple Pie Pumpkin Pie

Steamed Fruit Pudding, Brandy Sauce

Chocolate Ice Cream Assorted Cake

Iced Watermelon

Roquefort and Swiss Cheese Saratoga Wafers

Coffee

Postum Cereal

THE EVANS
HOT SPRINGS, S. D.

SUNDAY
JULY 23, 1905

EVENING MUSICAL PROGRAMME

BY THE EVANS ORCHESTRA

MR. OLIVER GUY MAGEE, VIOLINIST
MR. RALPH D. ROSENKRANS, CLARINETIST
MISS ELEANOR OSTLUND, PIANIST

ASSISTED BY

MRS. GEORGE BURBERRY, SOPRANO
MISS EDNA HOPLEY, SOPRANO
MRS. ANNA NOTT-SHOOK, READER
MISS GERALDINE CLAPP, ACCOMPANIST

SUNDAY, JULY 23, 1905

1. Overture, "Franz Schubert" *Suppe*
 Orchestra

2. Vocal, "Face to Face," *Johnson*
 Mrs. Burberry

3. Selection, "The Serenade", *Herbert*
 Orchestra

4. Reading, "Going Away,"
 Mrs. Nott-Shook

5. Vocal, "Message of the Rose," *Gottschalk*
 Miss Edna Hopley

6. "Intermezzo Sinfonico," *Mascagni*
 Mr. Magee

7. Concertstuck, "Bohemian Girl," *Balfe*
 Orchestra

The Evans Hotel was one of the fountains of culture during this event on July 23, 1905.

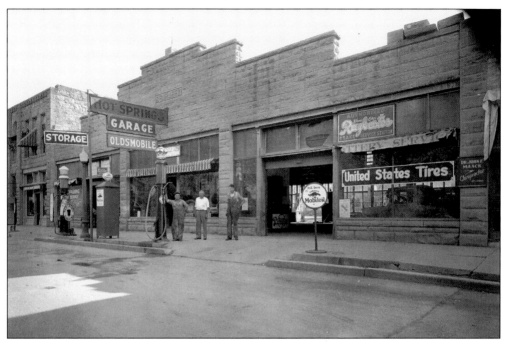

As cars became more prevalent, the necessary services sprang up. The Hot Springs Garage, at 713 North River, was owned by the Larive family. A Model T Ford can be see inside the window.

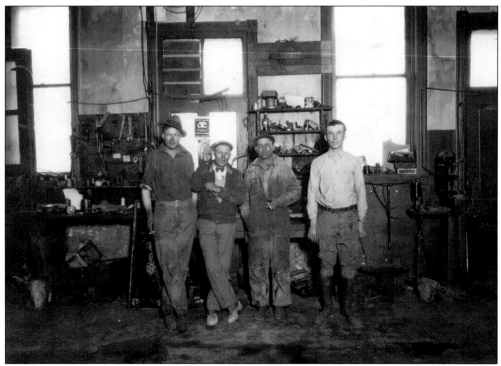

This interior shot of the Hot Springs Garage shows worker Slim Larson on the left, the others are unidentified.

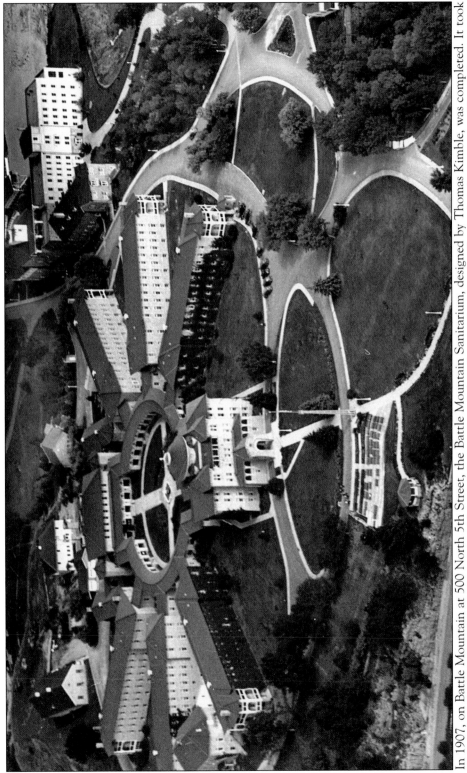

In 1907, on Battle Mountain at 500 North 5th Street, the Battle Mountain Sanitarium, designed by Thomas Kimble, was completed. It took four years to build this million-dollar national hospital for veterans. It later became known as a Veteran's Administration Hospital.

57

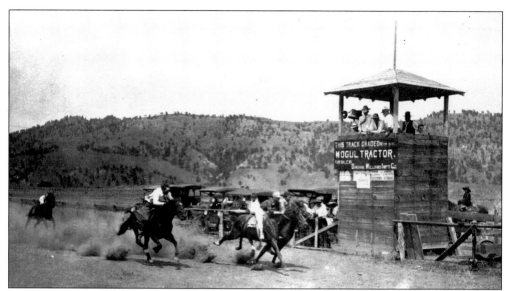

Butler Park was the setting for these horse races in 1919. Horse cart races had been featured in 1917. There were no bleachers so the people watched from buggies or on horseback.

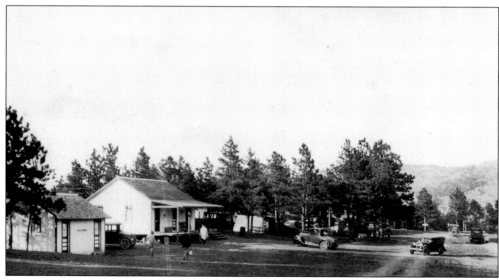

The Evans Heights Tourist Camp was a popular destination for visitors to Hot Springs. The camp store, restrooms, and showers were provided for those who stayed in the cabins or camped in tents at the site. The camp store advertised that it charged the same prices as the town store. It was promoted as being on the "Atlantic, Yellowstone, and Pacific Highway," or the A.Y.P.

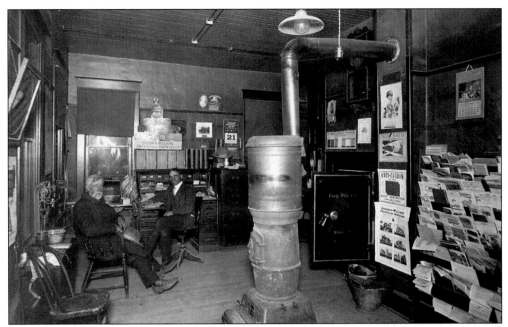

Lumberman Benjamin J. Glattly and his brother Soloman Benjamin, are shown in the interior of their lumber company in Hot Springs. Ads for Sherwin Williams Paints and Varnishes, Peoples National Bank, Anti-Carbon Soot Remover, John Deere of Moline, Illinois, and the Cary Safe Company of Buffalo, NY are visible. (Photo courtesy of Fall River County Museum, Hot Springs.)

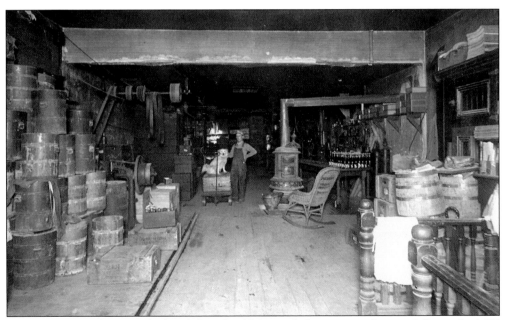

Hot Springs Bottling Works bottled and sold Minnekahta water, plain and flavored. A.W. Riordan and G. L. Thorp owned both this plant and the Hot Springs Fruit and Produce Company. Water was shipped as far as Ohio and Pennsylvania. Bill Richer worked there from 1906 through 1916. By 1912, he was earning $50 a month. (Photo courtesy of Fall River County Museum, Hot Springs.)

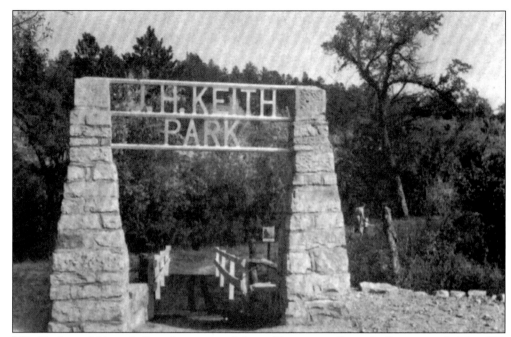

J.H. Keith and his wife Josephine moved from Chicago to Cascade Springs with Mrs. F.T. Allabaugh, sister of Josephine, in 1880. One of the Keiths' daughters, Edna, married Col. George Florence and they planned to make a summer resort at Cascade Springs in later years. It was never to be and Edna gave the land to the U.S. Forest Service for the J.H. Keith Park, in memory of her father.

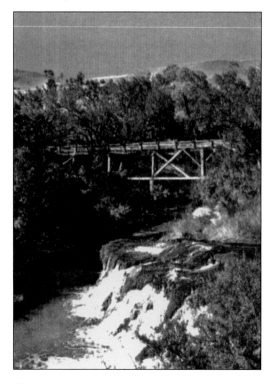

This is the old wooden flume that carried water over Cascade Falls to the Roe Irrigation Ditch.

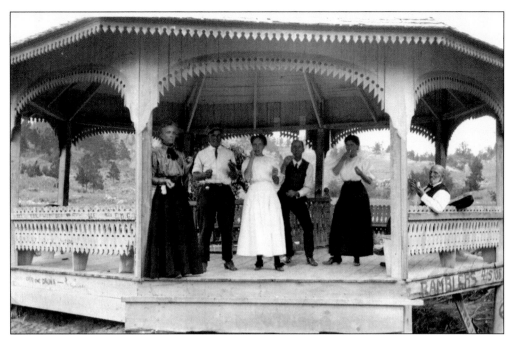

A pavilion was constructed at Keith Park for events such as this where "The Ramblers" performed. It was also used for a picnic shelter and is still in use today.

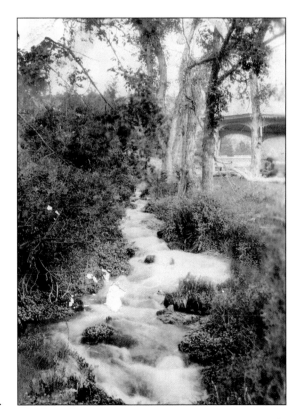

Just north of the pavilion is the actual Cascade Springs in Keith Park. It used to be a geyser but vandals stuffed it full of trash and it became a flowing stream.

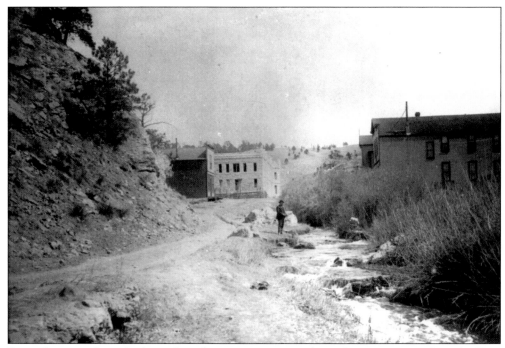

River Street at Cascade showed sandstone construction from the quarry near Cascade. Four hundred people lived in Cascade in the early 1900s.

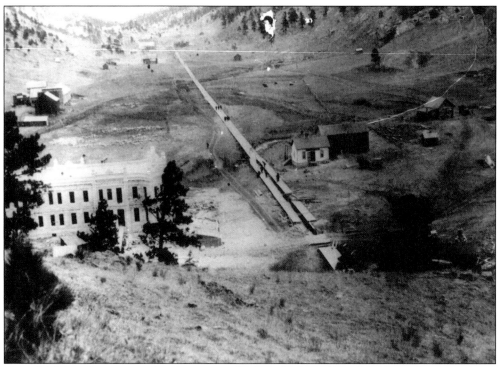

Cascade's Main Street was a lovely promenade through the valley. Forty-seven businesses were located in Cascade, including Wells Fargo and Company Express.

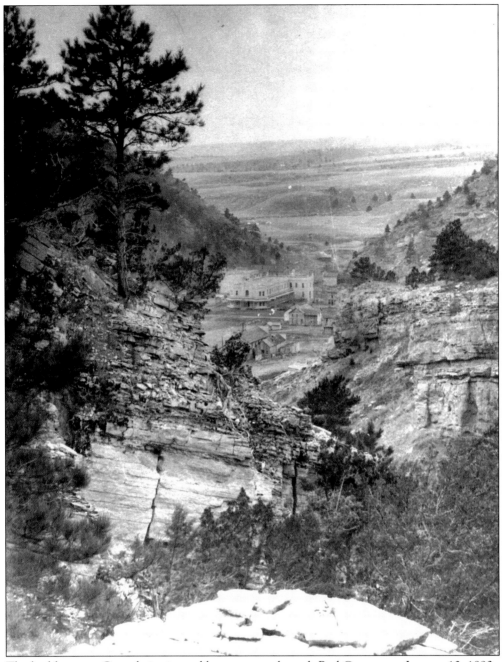

The bathhouse at Cascade is pictured here as seen through Red Canyon on January 10, 1893.

The houses on this page show progress and hope for the Tillotson family. The first house, built in 1881, was a log cabin and the construction of the stone house soon followed.

In 1906, this house was built at Glencoe Ranch near Cascade.

"Make do and repair" were the bywords of the time. Here, Hattie Tillotson is shown darning socks. The sock was stretched over a horizontal bottle that was on a stand. The bottle allowed easier access with the needle, kept the sock somewhat taut, and helped make the darned part smooth.

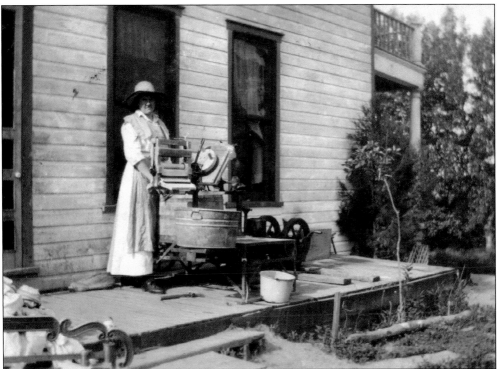

These laundry conveniences were a far cry from using a washboard at the creek. The wringer was especially helpful.

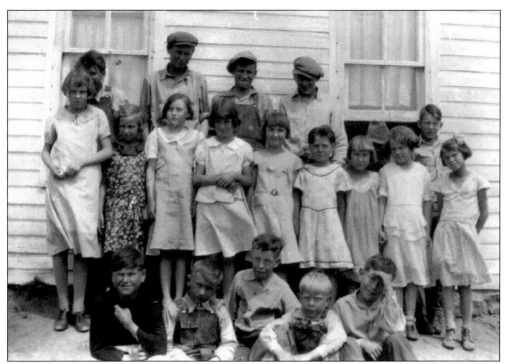

The students at Coffee Flat School near Cascade in 1933 are not positively identified in order but their names were: Bus, Grace, Kenneth, and Fern Halls, George, Donald, Ralph, and Leila Finley, John Rice, Doris and June Pierce, Nila and Ruth Barney, Shirley, Eva and Leslie McClure, Donald and Marvin Taylor, Sheila Hill, and Russell Wyatt, who was in the first grade.

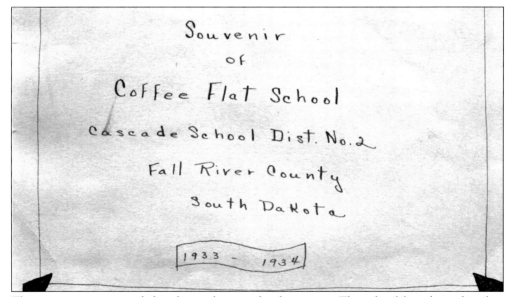

This memento contained the above photo and a few verses. The school board was listed as Mrs. Ray Pierce, Mr. J.H. Taylor, and Mr. John Schultz. Mrs. Hazel Peterson was the county superintendent and Miss Helen Sweeney was listed as her deputy. Miss Ruth Wight was the teacher.

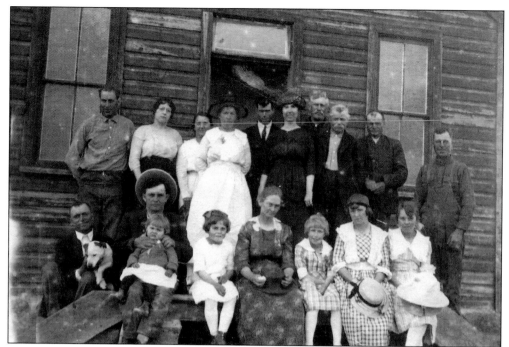

Interested parties attending a 1920 Maitland School meeting, from left to right, were Herman Peters, with his dog, O.H. (Shorty) Rauhauser holding Romain Rauhauser, Clara Rauhauser, Mrs. Ben Heindel, Freda Heppner, Anne Heppner, and Louise Rauhauser (later Mrs. Levi Madsen). The back row, included A.J. Landers, Mrs. Herman Manke, Mrs. O.H. Rauhauser, Mrs. Charles Heppner, John Radcliffe, teacher unknown, Charlie Heppner, Barney Kurth, and George W. Landers.

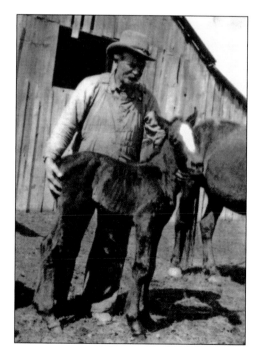

Horses were a vital part of the settlement of the county. This new colt is pictured near a barn in the care of Ira Tillotson.

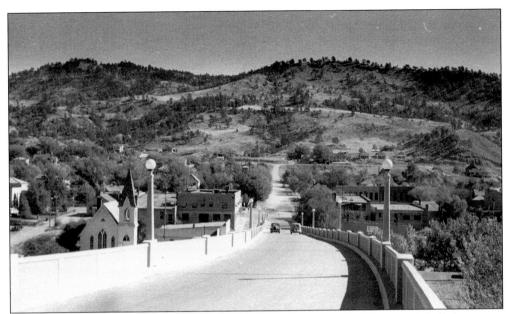

In September of 1945, this is how the viaduct in Hot Springs looked. It extended all the way to the Bering building. The Church of Christ building was later sold to the Elks and became part of the Elks Club. (Photo courtesy of Fall River County Museum, Hot Springs.)

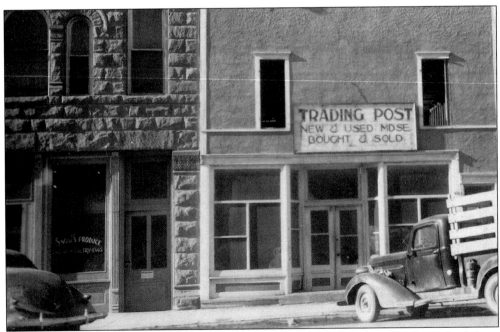

Snow's Produce, on the left, bought and traded cream and produce from local people. It later became the Wagon Wheel Bar. Bill Shattuck ran the trading post or second hand store where Russell Wyatt purchased his first .22 caliber rifle. Russell earned 50¢ per week from his father, Lyston, for work on the family ranch and truck garden. In turn, Russell paid this same amount weekly to Shattuck toward the gun purchase until it was paid for and he could take the rifle home. (Photo courtesy of Fall River County Museum, Hot Springs.)

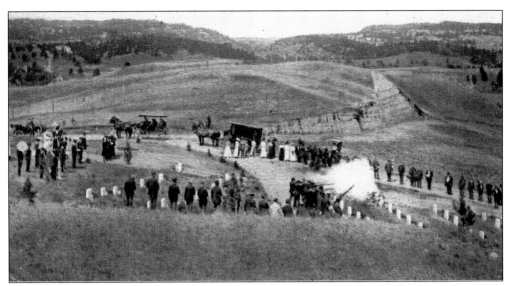

Memorial Day was originally called Decoration Day. This photo shows a salute over the graves in the Battle Mountain Sanitarium cemetery. (Photo courtesy of Fall River County Museum, Hot Springs.)

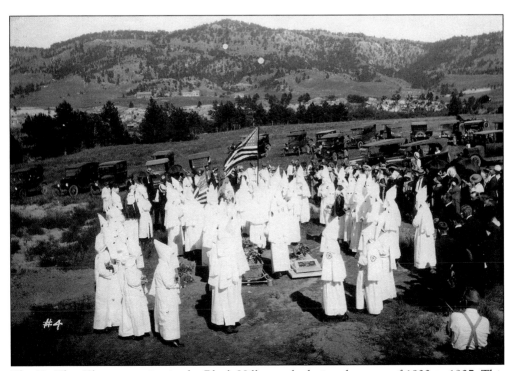

The Ku Klux Klan was active in the Black Hills mostly during the years of 1922 to 1927. This funeral at Evergreen Cemetery in Hot Springs was that of LouElla Cox on July 12, 1925.

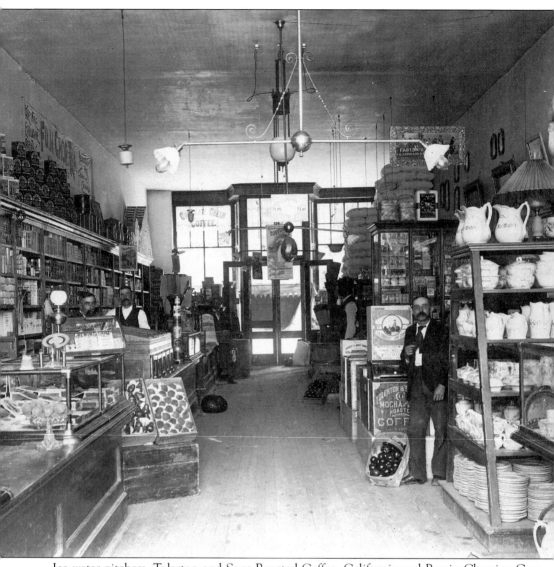

Ice water pitchers, Tolerton and Sons Roasted Coffee, California and Pepsin Chewing Gum, smoke pork and bacon, and Garicosa could be found inside the J.G. Richer and Company grocery store in 1896. The scale was made by the N.K. Fairbanks Company. (Photo courtesy of Fall River County Museum, Hot Springs.)

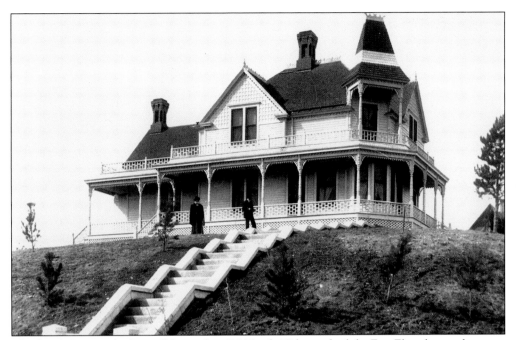

This lovely home, which is still located at 438 North 17th, was built by Ezra Elsey, hence the name of the landmark, "Elsey Hill." (Photo courtesy of Fall River County Museum, Hot Springs.)

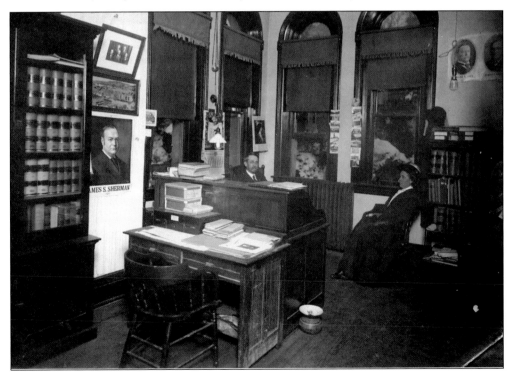

The law office of S.E. (Stephen Eugene) Wilson, the first superintendent of schools in Hot Springs, is shown here. His daughter, Edith, is pictured with him. (Photo courtesy of Fall River County Museum, Hot Springs.)

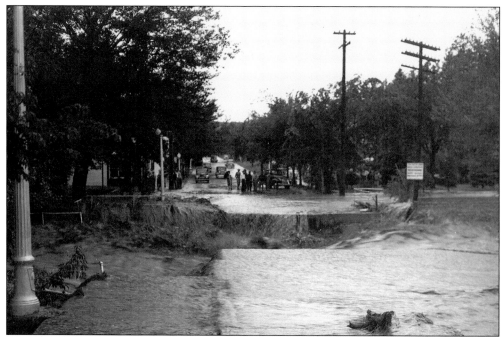

A flood in 1927 washed out the bridge in front of the Evans Hotel. This was the view looking west up Minnekata Avenue.

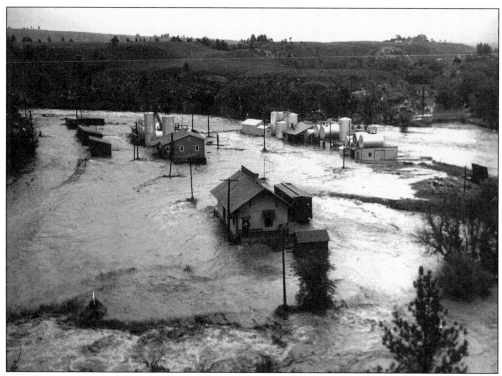

The flood in Upper Town in 1947 is shown in this view across from the Fall River County Courthouse.

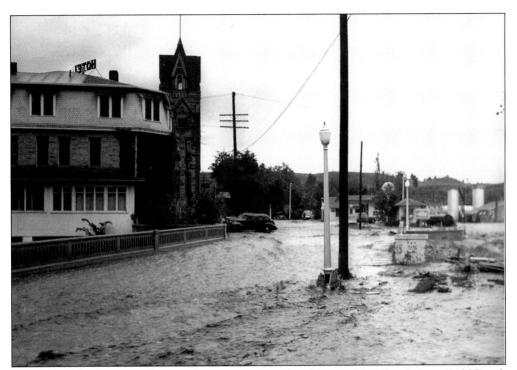

The Braun Hotel, next to the courthouse, was also affected by the 1947 flood. Once Cold Brook Reservoir was built in 1954, the floods that had plagued Hot Springs over many years finally ceased. The addition of the Cottonwood Dam further boosted the safety of the town.

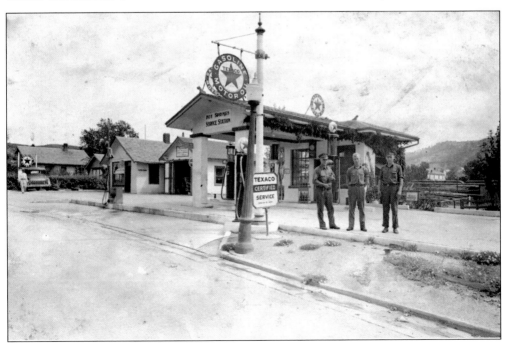

The Hot Springs Service Station featured Texaco products, including kerosene. It was located across the street and to the east of the courthouse. Art Hagen is on the right.

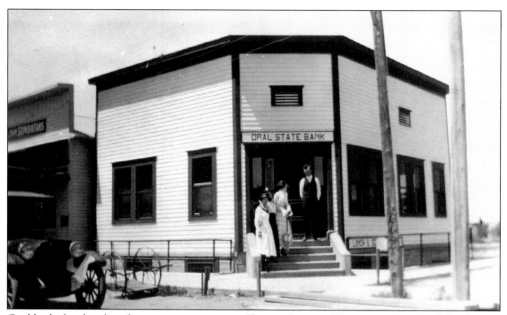

Oral had a bank, a hotel, a newspaper, a post office, and stores. The town was named for the son of Samuel Henderson, the first postmaster. The town was platted with streets named Mosier, Barnard, Goodman, Weldon, River, Birkeier, Ahern, View, and Cliff running north and south. First, Second, and Third Streets ran east and west.

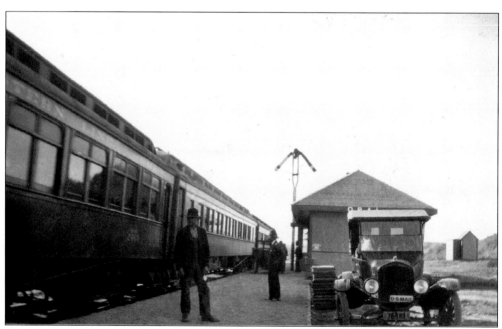

The depot in Oral was a busy place serving passengers and freight trains. Property values increased with time. The cost for two lots in 1907, sold from Goodman to Lorena Weldon, was $20. In 1921, two different lots sold from Ahern to the Odd Fellows for $175.

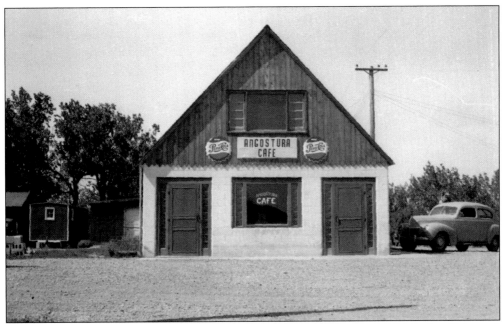

Kate Kazmer ran this Angostura Café in Oral for many years. In June of 1954, Jackie (Johnson) Swigert had her first job in Oral waiting tables for Kate. It is now Kate and Harry McClung's private residence in Oral.

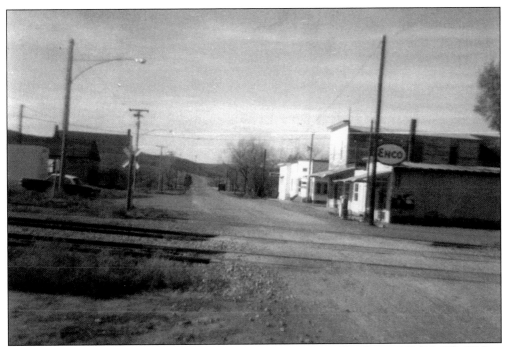

Main Street in Oral had a store and gas station as well as an Odd Fellows Hall (IOOF). Wilbur Emick owned and operated the general store in Oral for many years beginning in 1935 when Wilbur inherited it upon the death of his father, J.E. (John Elmer). Wilbur and his wife, Opal, also ran a ranch, which is still in the family.

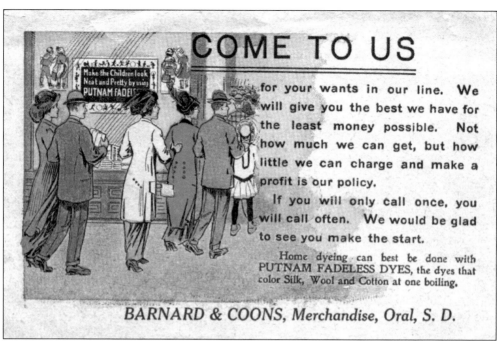

COME TO US

for your wants in our line. We will give you the best we have for the least money possible. Not how much we can get, but how little we can charge and make a profit is our policy.

If you will only call once, you will call often. We would be glad to see you make the start.

Home dyeing can best be done with PUTNAM FADELESS DYES, the dyes that color Silk, Wool and Cotton at one boiling.

BARNARD & COONS, Merchandise, Oral, S. D.

Barnard and Coons advertised their business in Oral with a postcard. The store was later owned by Elmer Goodman, opening under his name on February 26, 1907. When the Goodman family moved to O'Neil, Nebraska, in 1910 the store was sold to Harry Thomas. The building adjoins the Oral Post Office.

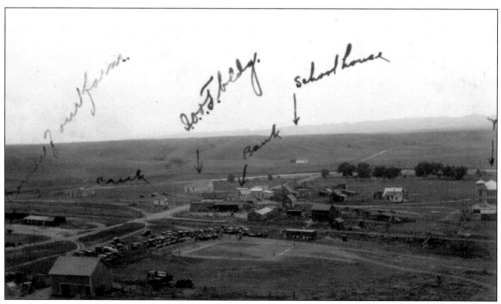

Baseball was a crowd favorite and a much enjoyed pastime. This photo shows the field along with a number of buildings in Oral. The IOOF (Odd Fellows) Hall, school house, creek, and bank are labeled.

Guy Weldon carried the rural mail in the Oral community from October 1, 1911 until January 31, 1917. The routes were run daily west of Oral and three times per week east of town.

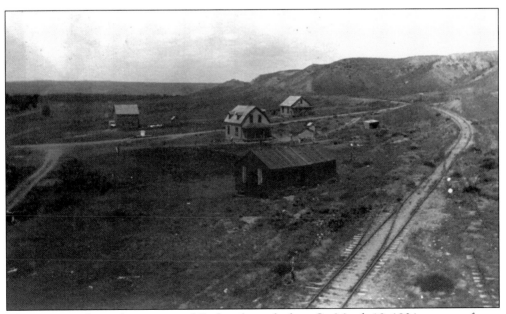

This overview shows the east part of Oral in the early days. On March 18, 1904, a group of men from Oral and the surrounding area gathered to gravel the Main Street. Their wives prepared a large meal in the basement of the Oral Church.

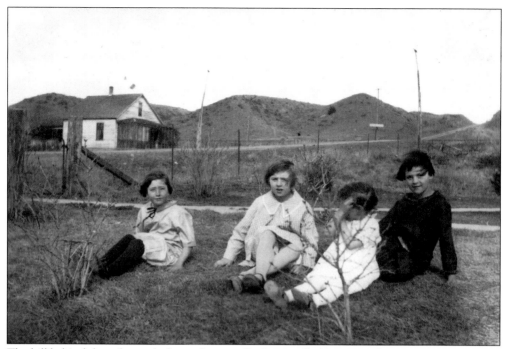

The hill behind these four girls, located in east Oral, was called Patton Hill. Myron Patton was the road builder who lived at the foot of the hill. His family helped establish the first school in Oral.

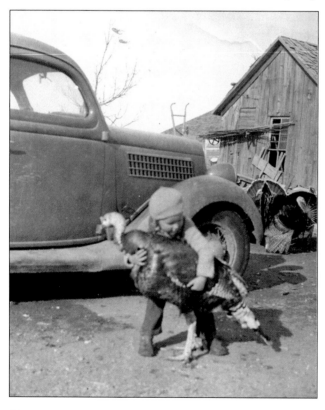

Barbara Hageman caught this big turkey at her grandpa L.A. Gorr's place. L.A. was known as Pop Gorr in the Oral community.

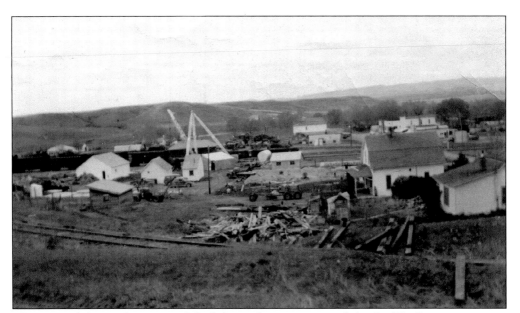

This view of the southern part of Oral shows the train cars and the "stiff leg" crane apparatus off-loading dry cement destined for the construction area at Angostura Dam. Buildings used by the Angostura Irrigation District, Emick's Store, and the Odd Fellows Hall can also be seen.

George and Ivah Bayne were pioneers who constructed their sod house themselves.

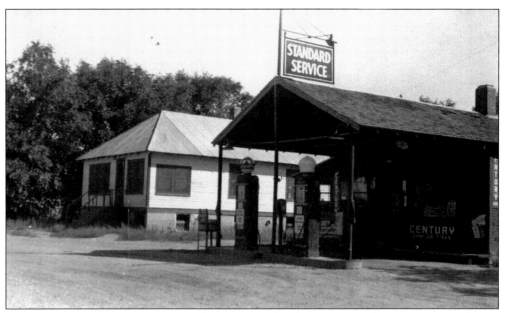

The Standard Station building in Smithwick was also the home of John and Elizabeth Seder. The sign shows they also sold Century Tires.

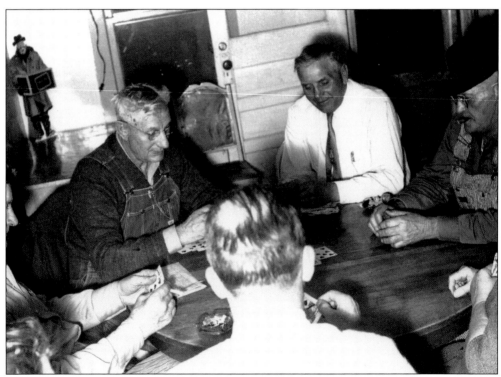

Just down the block from Seder's in Smithwick was Vi's Café. Vi was a sister to Bert Thompson, the fellow with the bald head. On the far left of the photo, others who can be identified are, from left to right, Leo Molitor, John Seder is in the overalls, R.C. Davison wore the white shirt, and Don Roll had the cigar.

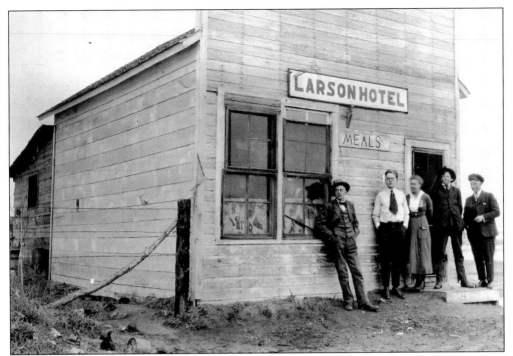

The Larson Hotel in Smithwick later became Vi's Café and the building still stands south of the Methodist Church.

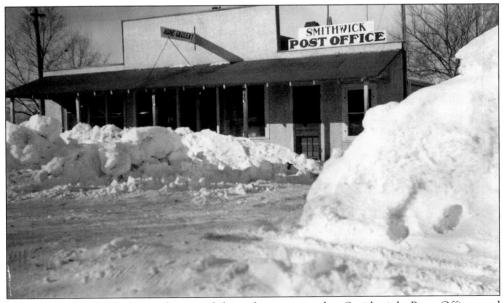

The Blizzard of '49 dumped a good bit of snow on the Smithwick Post Office and Home Grocery.

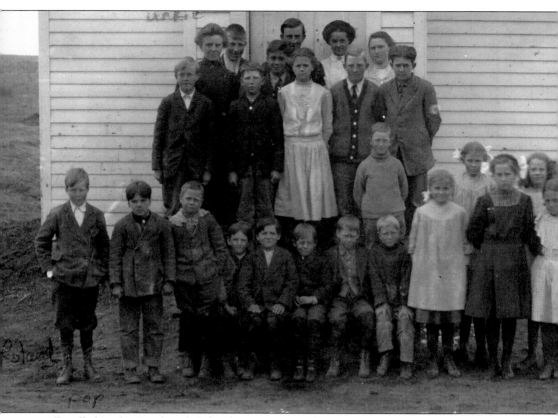

Enrolled in the Smithwick School in 1911 were, from left to right, front row; Roland Larson, Earl Perreault, Clarence Reaser, Albert (Pete) Perreault, Marion (Buck) Perreault, Glen (Mike) Reaser, ? Strain, Walter Jones, Genevieve Frawley, Mattie Frawley, Garnet Strain, Mildred (Sis) Reaser, and Violet McFee. Next were Dan Larson, Guy Jones, Roy McFee, Clara Reaser, Claud Jones, Guy Heniger, and Rex Jones. Top row included Miss Shay, the teacher, Thomas Frawley, Preston Jones, unidentified, and Leafy Jones.

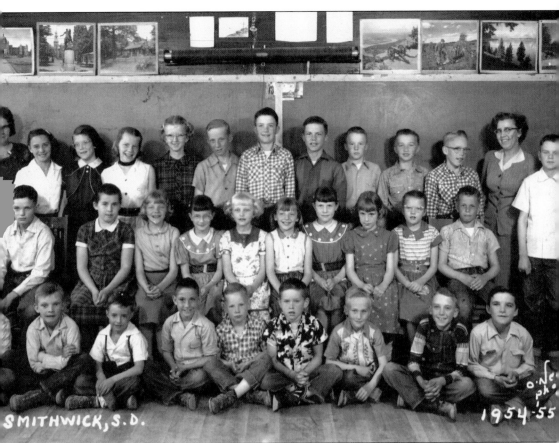

SMITHWICK, S.D.

1954-55

The Smithwick School continued to grow and in 1954 had 30 students and 2 teachers. Pictured here, from left to right; Gordon Mueller, Bob Bowker, Wayne Morgan, Jerry Gilkey, Steve Kienitz, Pat Gilkey, Warren (Butch) Benson, Harvey Crapo, Gary Bowker, John Sides, Jo Gilkey, Betty Ferguson, Mary Lou Hallet, Lois Olson, Laura Ferguson, Patty Hallet, Delores Kienitz, Anita Hamblin, Jimmy Kienitz, Mrs. Carty (Oleanna Ash)—teacher, Janet Crapo, Janice Kienitz, Deanne Ferguson, Lucille Olson, Gary Rasmussen, Donnie Fish, David Ferguson, Dean Fish, Verel Benson, Larry Mueller, Louise Renz—teacher, and Dennis Bowker.

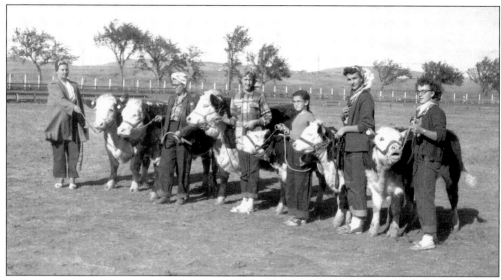

4-H was a favorite activity over the years. Violet Perreault and Virginia Thompson, mothers, were holding the extra calves. In the summer of 1950, these 4-H members, Clara Benson, Barbara Perreault, Bernadine Perreault, and Kay Thompson, prepared their calves for showing.

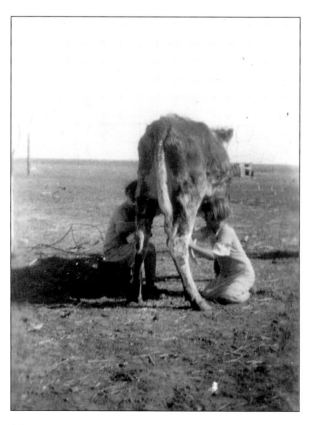

The Kain twins milked the cow right out in the pasture in Hay Canyon, east of Oral.

Three

LIVING OFF THE LAND

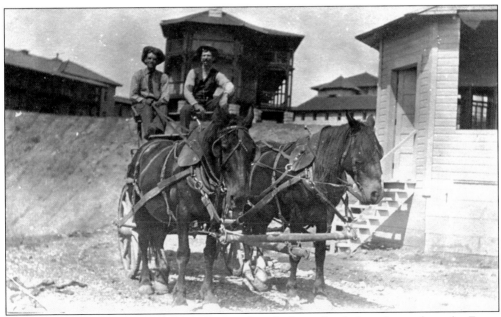

George Washington Bledsoe, left, and an unidentified man hauled sandstone from the Evans Quarry to the Battle Mountain Sanitarium during construction. That contract alone called for 75,000 tons of stone.

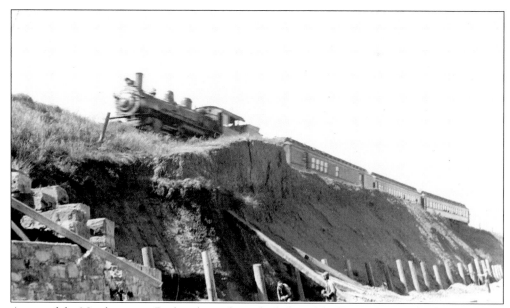

A spur of the Northwestern Railroad ran along the ledge of the Evans Quarry, facilitating easier shipment of the pink sandstone. Located about 3 miles from Hot Springs, the quarry was a 20-acre tract and part of a 320-acre ranch.

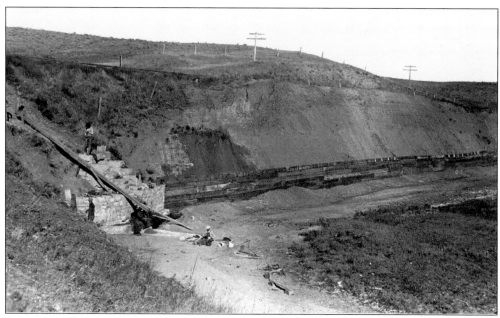

Stone from the Evans Quarry was also used in the Evans Hotel, the adjacent Minnekahta business block, and the Gillespie Hotel, among other buildings in Hot Springs. The Sioux City, Iowa Public Library was one building also constructed from the Evans' stone.

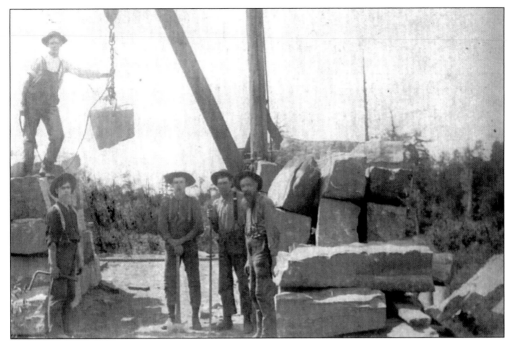

These unidentified quarry workers show a few of the tools of the trade.

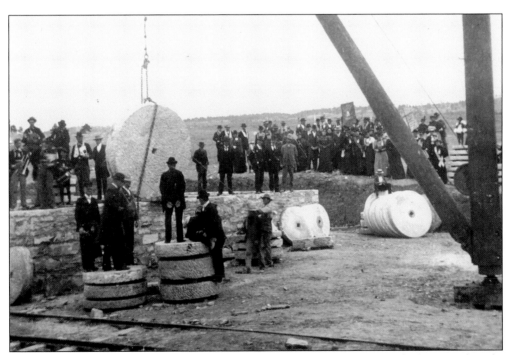

Red Canyon, not far from Edgemont, had a sandstone quarry that yielded what was thought to be one of the finest qualities of grindstone material in the world. It was discovered in 1893 or 1894 when the Edgemont Company opened up the mountain looking for building-quality sandstone. The Grable Block and the Edgemont Block were constructed from this quarry.

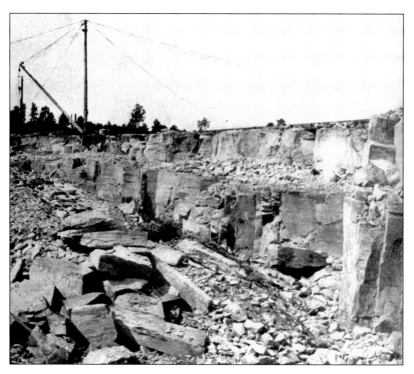

As the stone was quarried, it had to be cut into somewhat manageable pieces in order to load it onto a train or into a wagon.

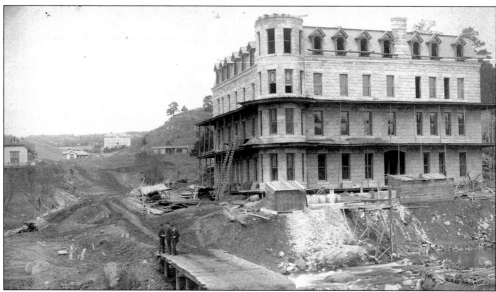

In 1889-1890, the Gillespie Hotel was built in Hot Springs. The South Dakota State Soldiers Home, in the background, opened in October of 1890. It remains open to South Dakota veterans and their spouses. Computers with internet access are available for residents' use. There are wide and varied activities and programs at the facility such as fishing and hunting, sewing, church services, library, crafts, and a wood shop. A leather worker and a seamstress each have their own craft rooms. The Federation of the Blind, Minnekata Quilters Guild, as well other groups, meet at the State Home and interact with the residents. They even have a chapter of the Red Hat Society! Health needs are also met with a pharmacy and physical therapy facility on site.

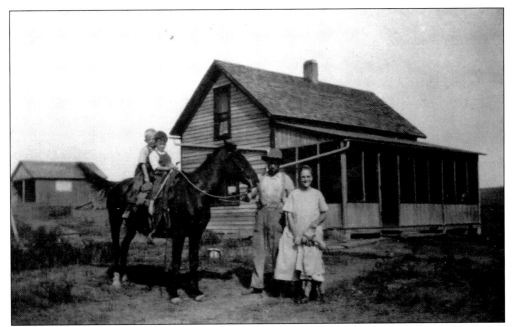

In 1911, L.O. and Ada Rickenbach homesteaded seven-and-a-half miles northeast of Oelrichs. Sitting on the pony, holding the reins, is their son, Joel. Behind him is his brother Max. L.O., Ada, and baby Don are standing. This picture was taken in 1923 in front of their homestead house. The ranch is still owned and operated by the Rickenbach family.

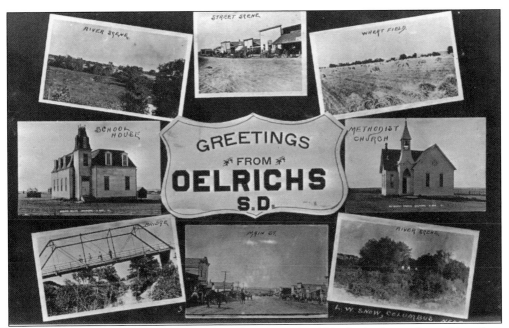

According to this postcard, Oelrichs had it all in the early 1900s. It also boasted a packing plant called the Oelrichs Abattoir Company and was a major livestock shipping point on the railroad.

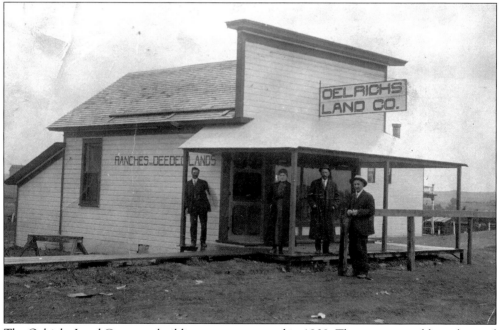

THIS IS A BUSINESS CARD

...AND IT IS YOUR BUSINESS TO GET A HOME...

Good Farm Lands that are open for Homesteads; also some fine Ranches, Farms and Raw Lands, Cheap.
LOCATIONS, TEN DOLLARS

WRITE, OR BETTER YET, COME AND SEE ME

L. D. BAILEY, OELRICH'S, S. D.
LANDS, HORSES AND CATTLE. FOR SALE OR EXCHANGE

Buy Cheap Land; It Always Makes Money

L.D. Bailey had many advertising slogans on his card. He was one of the sons of Phoebe Stolp Bailey who died on August 9, 1909 in Oakdale, Nebraska.

The Oelrichs Land Company building was constructed in 1909. The company sold ranches and handled deeds.

The extension service was an outreach of the state's land grant college, South Dakota State University. The extension's mission was to educate farmers, ranchers, and homemakers in the latest procedures to improve their lives. In 1931, this hog cholera vaccination demonstration was given.

The Oelrichs Purebred Gilt Club, with J.T. Bowyer as the leader, encouraged and educated young people who raised hogs.

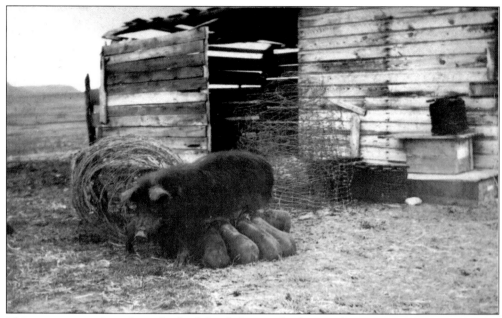

This mamma pig shows how she feeds her babies in the barnyard.

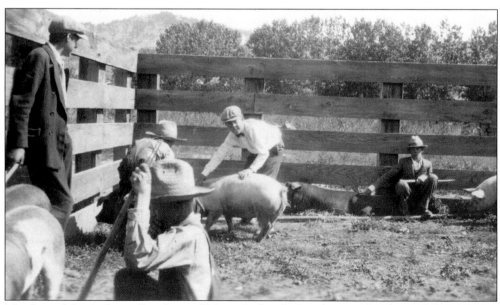

Members of the Ardmore Sow Litter Club worked with their hogs as they learned about them.

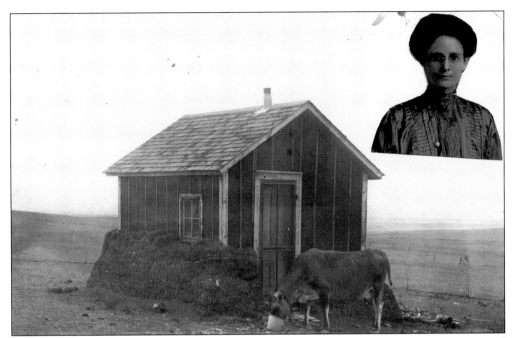

The claim shack and cow apparently belonged to the unidentified lady in the inset. Married women were not allowed to claim homesteads on their own at the time.

In 1926, the photo of this ingenious set of farm butchering equipment was taken on the V.E. Nelson farm.

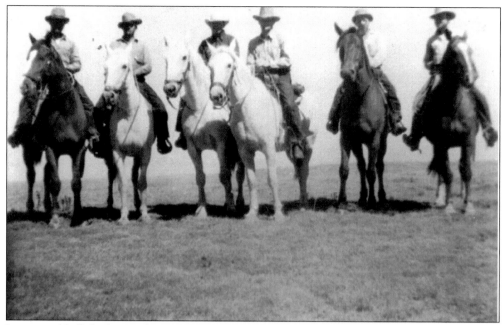

Just six old Oelrichs cowboys....not quite. Four of these six went on to be elected into government positions. Joel Rickenbach was a state representative from 1974 to 1984. Pete White was a state representative from 1962 to 1965. Next is Roland Zimmerly. Jack Manke was a state senator from 1980 to 1985. Next is Billy Kneebone. J. D. Melcher served in the Montana state legislature and was a U.S. Senator. He was a step-son of Ed White from Oelrichs.

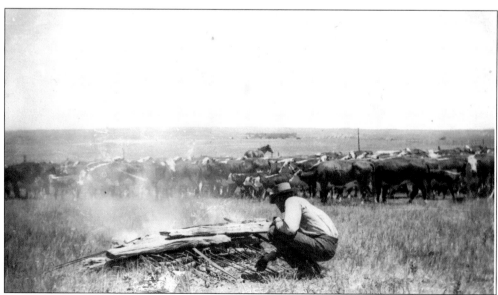

Jack Manke was laying the branding irons in the fire on June 22, 1946.

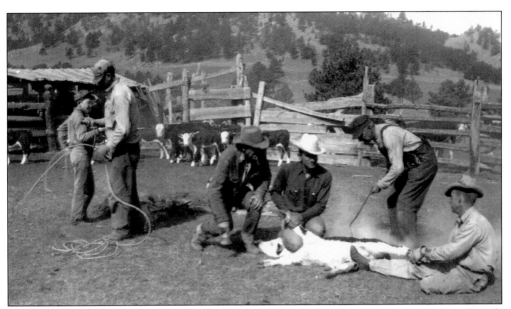

A brand is simply a sign of ownership, rather like the license plate on your car. Brands are also registered with the state and are a legal mark. The location of the brand is part of the description.

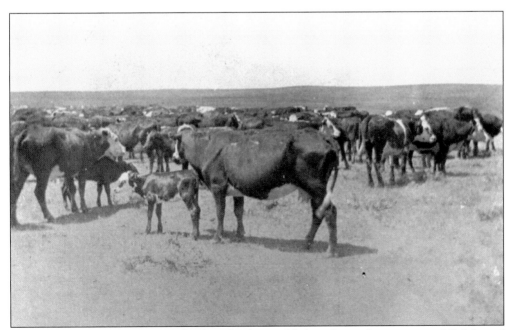

The star brand on this cow's left ribs tells the world that she is the property of Ralph and Bernice Landers of Cascade, which is south of Hot Springs.

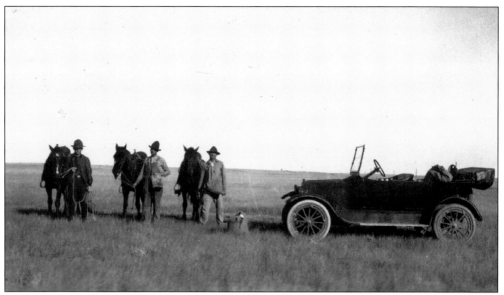

Even in 1925 prairie dogs were a huge problem for ranchers. This Rodent Control Squad was preparing to do battle with the pests. The Squad's work yielded complete eradication of the animals on 37,150 acres of land. In addition, 7,800 acres were treated by private landowners.

NAME Wehnes

ADDRESS ..

Section N½NE¼ Section 5

Township 7 Range 9

........ Fall River County,

PRAIRIE DOG CONTROL

When treated Sept 14th-25

Cost ...

Retreated 9/23/25

Cost 80 acres $7.50

Remarks 14 miles northeast

Oral near Jack Lammon's

Extended 9/25/25

D. Billups.
 Fieldman

This Prairie Dog Control card was used by the field man who was hired by the county to poison prairie dogs, field mice, and striped gophers. Individuals did the same on their own land. In 1930, 54 farmers used 239 pounds of poison bait in attempts to control the creatures.

Claude Tillotson did not seem very excited about his meal prospects. A cowboy on the range frequently was his own cook.

While it was not exactly a picnic, these cowboys enjoyed their lunch break. The man in back was C.W. Landers, the man with his foot resting on a wheel was G.W. Landers, and the rest are unidentified.

In August of 1945, a group of Minnekahta ranchers got together to hold a little fun rodeo. Shirley McClure was one of the ranchers who dressed up in women's clothing for one of the events.

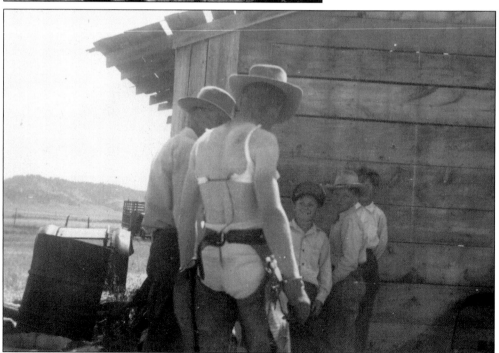

Shirley McClure showed the back of his feminine side.

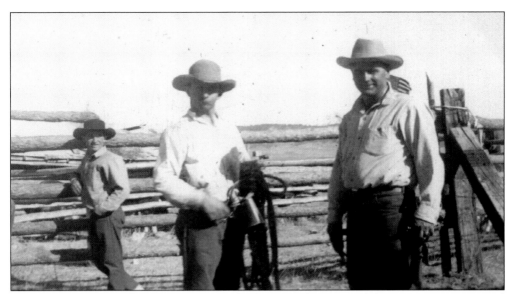

Henry Marty, Ben Miller, Byron Cox, and Alvin Knight prepared for a more conventional rodeo competition. After working on the Bar T Cattle Company for awhile, Marty was the first mortician in Hot Springs. He ran that business along with his furniture store.

Don Nelson and Herb Drain counted their winnings after the rodeo jackpot.

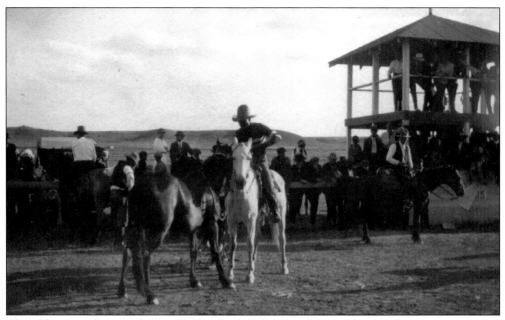

This old time rodeo was also put on for the amusement of the cowboys and spectators.

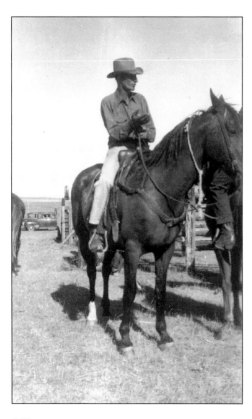

Don Nelson put on his glove as he prepared to compete. He was a renowned Registered Hereford breeder.

This was just good old fun. Here, Neal Allen and Dale Miller ride Alvin Knight's trained mule at the Minnekahta rodeo.

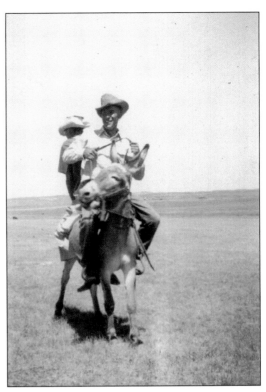

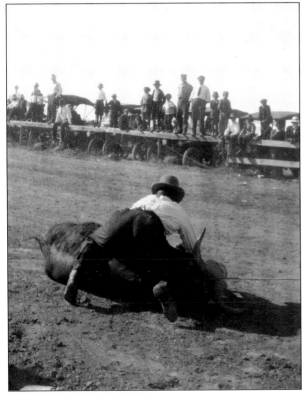

A cowboy had his hands full in the rodeo arena. Both he and the steer had a good tussle.

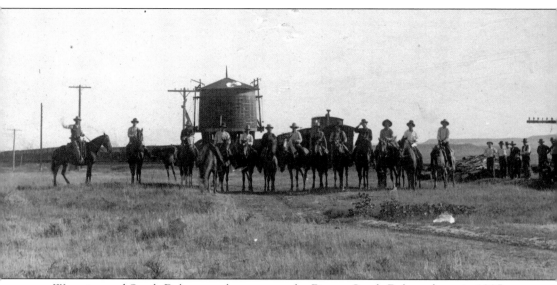

Wyoming and South Dakota cowboys met at the Dewey, South Dakota depot in 1905.

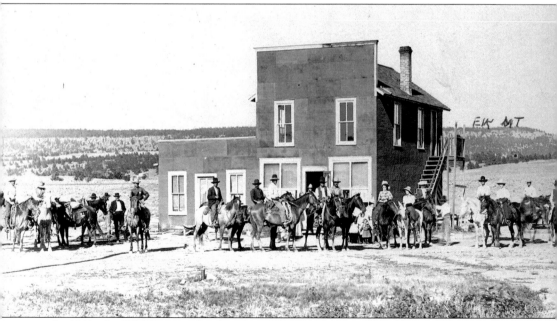

In 1910, the W. Matteson family opened their first store and added a post office with their living quarters on the second floor. Their customers were mostly the cowboys and ladies from the Dewey area. Elk Mountain is seen in the background.

These cowboys may have been freed slaves from the south, or Civil War soldiers who had been discharged. How they ended up as hired hands for A.J. Landers near Cascade is not known, but at least one knew how to ride an ill-tempered horse.

The TOT Ranch house was also a stage coach stop on the Cheyenne-Deadwood Trail. It was at Dudley, which is north of Edgemont, across the Cheyenne River.

Before horse trailers, this is how horses were moved in vehicles.

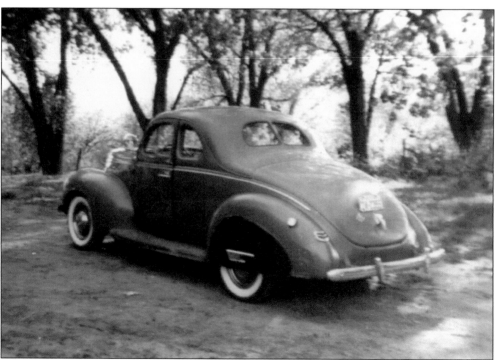

This 1940 Ford coupe was owned by Russell Wyatt of Cascade. It had an 85 horsepower motor that went 100 mph with no problem. The teal green car got 23 miles per gallon on a trip he and Blaine Halls made to California.

104

Hattie (Lindsay) Tillotson and her sister Erepta (Rep) Lindsay were congratulating each other for something—perhaps buying the car or learning to drive it.

This touring car was full of people and ready for a Sunday drive.

The speed of a horse drawn mower sickle was controlled by the gait of the horses. If they walked too slowly, the machine plugged up. Ira Tillotson is cutting hay in this photo.

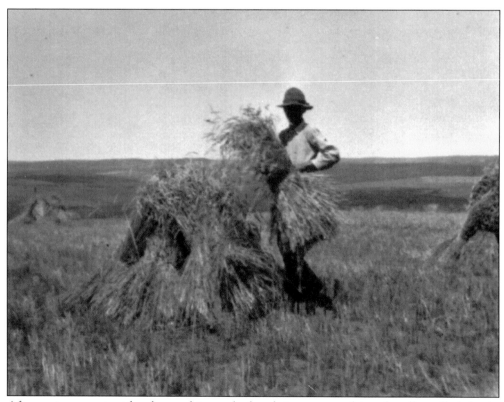

After grain was cut, either by machine or by hand, it was moved into bundles called shocks or sheaves.

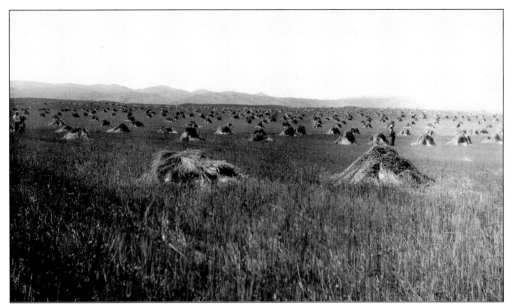

In 1925, this Pure Seed Project wheat field, raised from county seed, had been cut and was all in shocks.

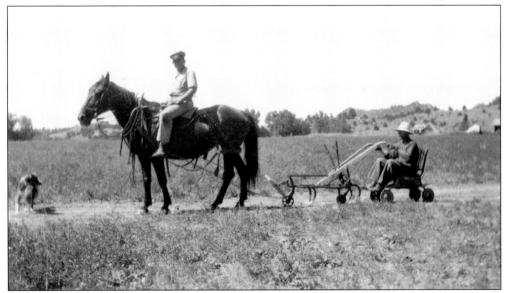

One system of getting rid of weeds was cultivating. The shanks on the cultivator would have been pushed down into the ground, tearing out the weeds. This photo actually showed Russell Wyatt on the horse and his father, Lyston, riding on a little wagon behind the cultivator, just goofing around.

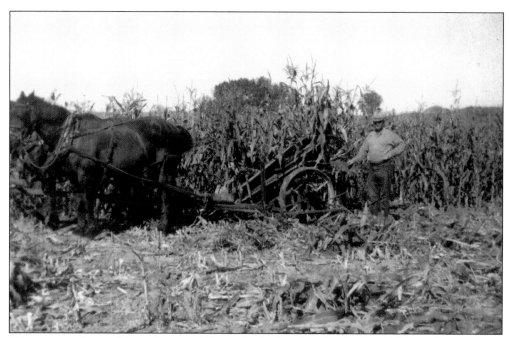

Corn was cut by machine when possible or else by hand with a big knife. It was then put into shocks and usually tied together with string. Charlie Halls was glad to have the up-to-date machinery which made the process go much faster. The machine also tied one string around each bundle.

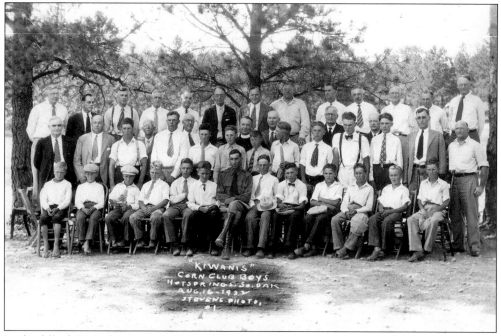

In the fall of 1924, the Kiwanis Club was organized in Hot Springs. One of their activities was to promote better understanding between rural and urban residents. The 1932 Corn Club, pictured above with members and sponsors, was one of the fruits of that labor.

Farmers and ranchers always had to try to outwit the pests that destroyed crops and land. At the Seed Show and Auto Show in 1926, a smut machine was displayed by the Minnekahta community.

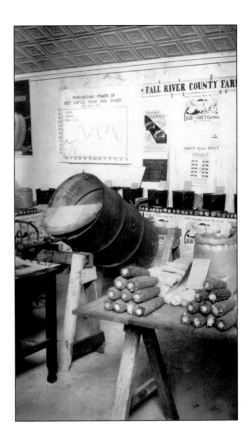

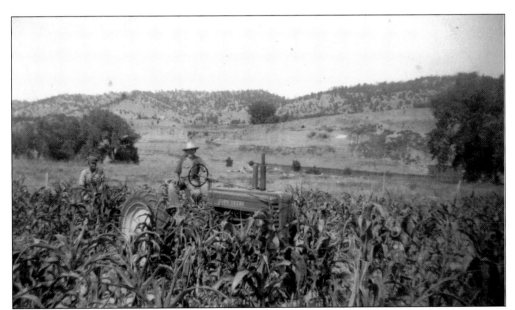

In further advancements to the cultivating process, the horse was replaced by a tractor, here driven by Harold Wyatt. In this photo, his brother, Russell, was walking behind, watching the process.

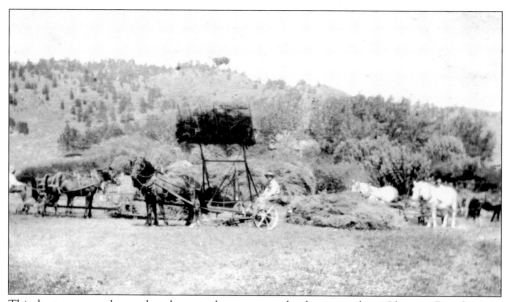

This horse-powered overshot hay stacker was on the homestead at Glencoe Ranch, near Cascade. It was a huge improvement over pitching hay onto and off of a wagon, a pitchfork-full at a time.

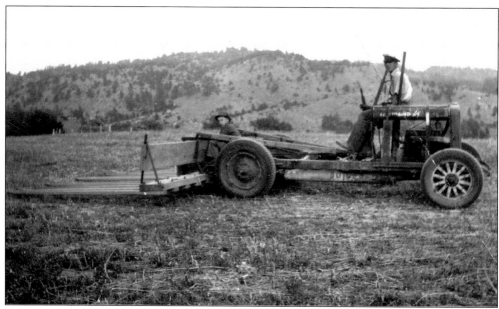

A converted 1928 Chevrolet car was made into a hay sweep, commonly called a buck rake. Russell Wyatt turned the transmission over so the vehicle went backwards in the forward speeds.

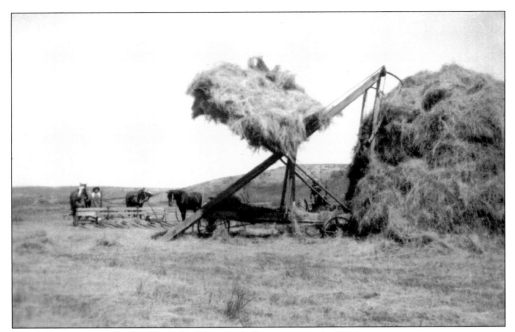

Bert Thompson of Oral still stacked hay with horse power in 1946.

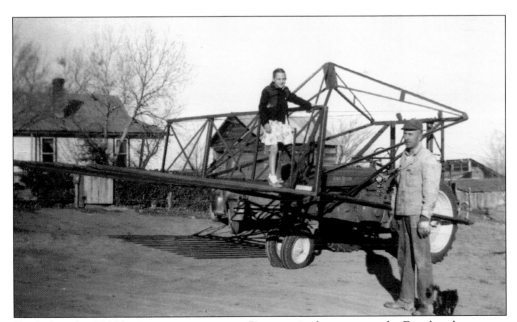

But before the 1946 haying season was over, Bert acquired a tractor and a Farmhand sweep.

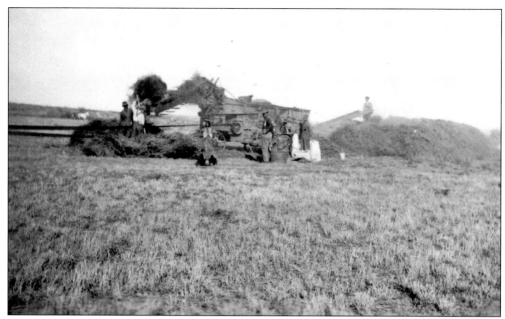

Threshing machines were used to take the grains or seeds from the plants. In this case the crop was a registered alfalfa field in 1930. The seed was called "Little Yellow Nuggets."

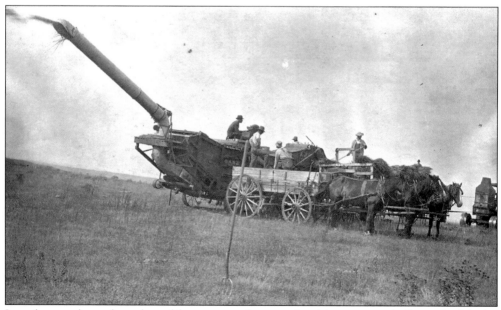

It took several people and good horses to make up a threshing crew and all involved had a specific job. Bundle haulers loaded the shocks onto horse-drawn wagons. They drove the wagons to where the threshing machine was set up.

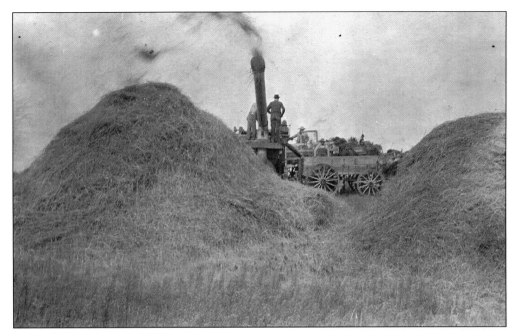

When the machine was ready, the wheat, oats, or other crops were tossed into the threshing machine by hand with pitchforks. Machines became more accessible as grain harvesting equipment companies numbered 160 in 1916.

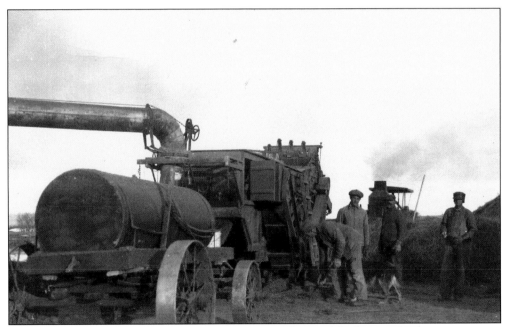

Steam threshers became a familiar sight, alleviating the need for horses. As the crop was run through the thresher, the grain was separated from the stalks. The grain was then carried by a chain elevator to a small hopper, which was also a measuring device. When it was full, the hopper was automatically tripped, and the grain was moved by the elevator into a wagon. An automatic counter kept track of the hopper loads.

The dog appears to be driving this Fordson tractor and disking the field.

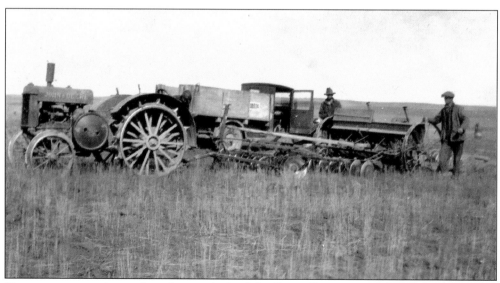

Two men were getting ready to farm with this John Deere D tractor and disk.

Dale Miller holds his son, Gene, on this McCormick tractor during a short break on a farming day. Barbara, Gene's mother, took him out to the field when she took a snack to Dale.

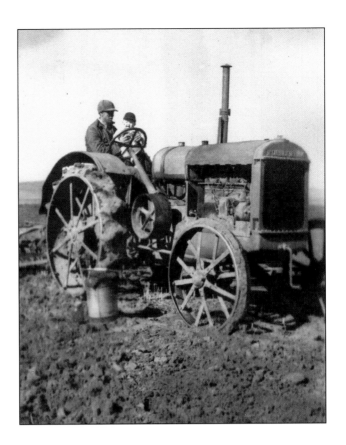

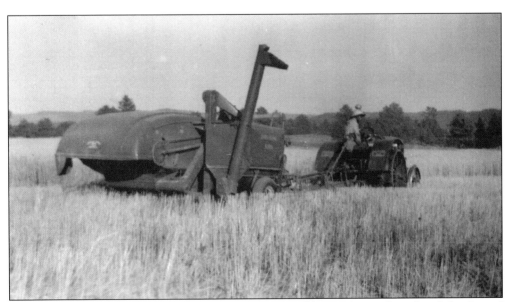

The combine could be pulled behind a tractor to cut and harvest grain. It replaced shocks and threshing machines.

Laura Landers of Cascade crossed Hat Creek on horseback in 1910 as she went about her business or visited the neighbors.

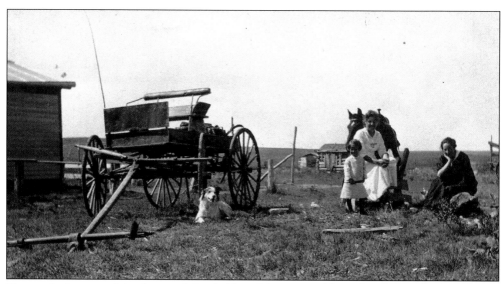

Next to the buggy and the dog stood the children, Margaret and Lizzie Landers, and Laura Landers (Mrs. C.W.). The saddle horse behind Lizzie may have been ridden to cross Hat Creek.

A group of area cowboys and businessmen played a good game of cards in Hot Springs. Their names, although not necessarily in this order, were Charles Keller, Jim Gillespie, Sedgewick, William Sawyer, Bill Crane, Chris Rheinma, Wally Root, Harry Morely, and Henry Marty.

Money changers in the temple? These advertisements were on the back of a weekly bulletin of the United Churches in 1936.

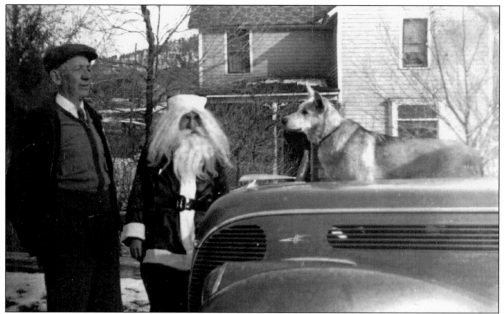

Dan Mosier, Santa (Mr. Klock), and Johnnie the Watchdog were a team from at least 1939 to 1941. They visited all of the rural schools and area hospitals, and took gifts to families who had a great number of children. Mosier owned the car and the dog; he transported Santa and Johnnie on their rounds.

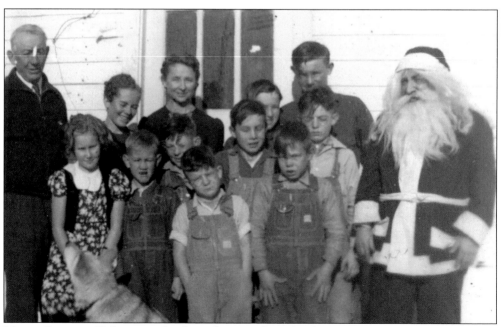

Mosier, Santa, and Johnnie took gifts to the WG Flat School in 1940. School members from left to right, were Barbara Hageman, Harry Nickels, Bobby Gamet, Dale Emery, Berdell Fleming, Ronnie Emery, Armor Fleming, Marcelene Fleming, Lillian Biggins was the teacher, Robert Emery, and Curtis Hageman. Santa brought each student a big, fat candy cane and other gifts, including a kaleidoscope one year.

UNITED STATES
DEPARTMENT OF THE INTERIOR
BUREAU OF RECLAMATION
MISSOURI RIVER BASIN PROJECT
MISSOURI OAHE DISTRICT-ANGOSTURA UNIT
ANGOSTURA DAM

HEIGHT ABOVE RIVER BED	135 Ft.
HEIGHT ABOVE LOWEST POINT OF FOUNDATION	190 Ft.
TOTAL LENGTH OF DAM	2030 Ft.
LENGTH OF CONCRETE SECTION	970 Ft.
SURFACE AREA OF RESERVOIR	6000 Acres
NORMAL STORAGE CAPACITY	160,000 Acre Ft.

After many difficulties, including World War II, a contract was let to Utah Construction Company on June 28, 1946 to build Angostura Dam. Dedication ceremonies were held once the dam was completed on September 29, 1949.

Before any dirt was moved to begin the construction on Angostura Dam, this is what the area looked like.

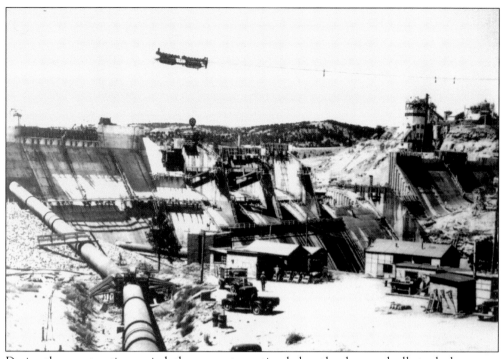

During the construction period, the concrete portion below the dam gradually took shape.

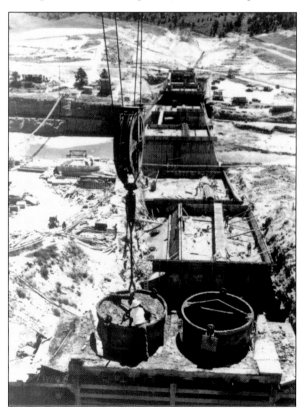

This cable assembly and setup was the transportation system for the cement used on the dam.

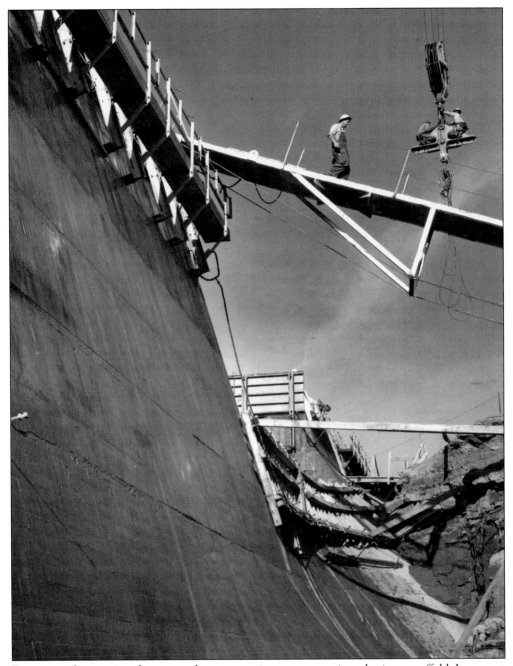

For many jobs, moving about over the construction area necessitated using a scaffold. It was not for those who were afraid of heights.

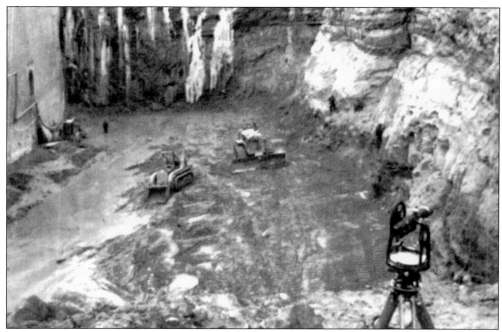

Men and dirt moving machines worked in the depths below the dam. A professional photographer was on hand to record events, sometimes even just at the moment of tragedy.

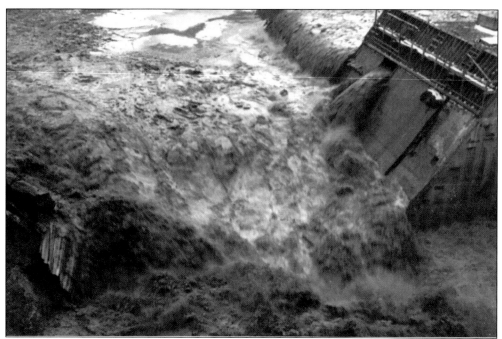

A coffer or diversion dam, that held back the Cheyenne River during construction, broke on March 16, 1948. Men using machines were drowned and their bodies were not recovered until the following August, even though divers searched for them over several days. Bill Keil, Donovan Brown, and Lloyd Elmer Hall were killed. Max Herbert clung to a cake of ice and was pulled out with a rope. Of course, the equipment was also lost.

This is an aerial view taken during the construction of Angostura Dam.

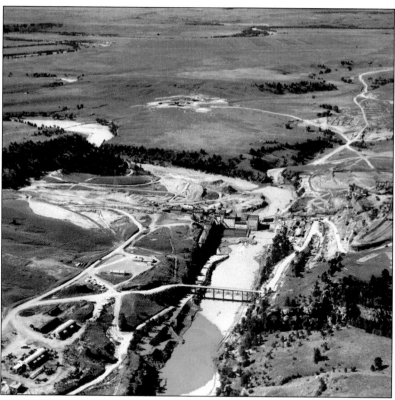

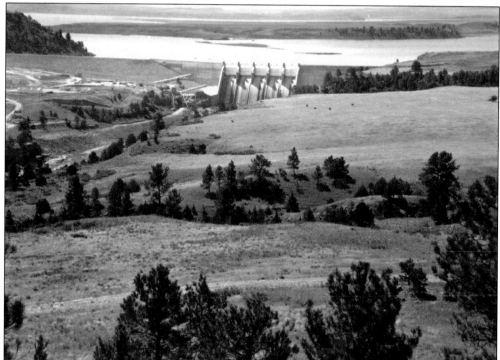

This is a view of the completed dam looking south.

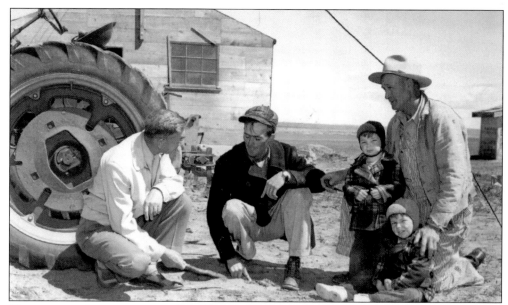

Plans were made—sometimes informally—as farmers prepared to plant crops on the Angostura Irrigation Project. Here, the county extension agent, Floyd Haley, and farmer, Don Peck, draw plans in the dirt as they discuss options. Jim Peck, standing, and his twin brother, Frank Peck, seated, were with their grandpa, Don's dad, Merle Peck.

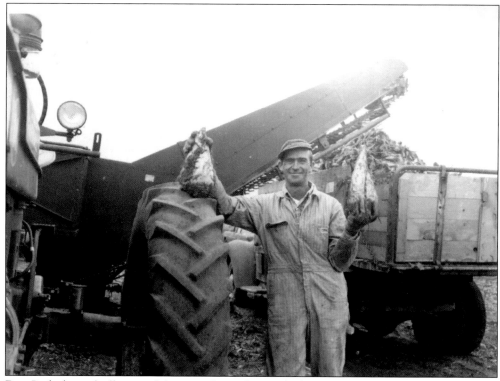

Don Peck showed off some of the sugar beets during the harvest.

LeRoy and Lyston Wyatt were visiting with Russell Wyatt while he took a brief break during beet harvest time.

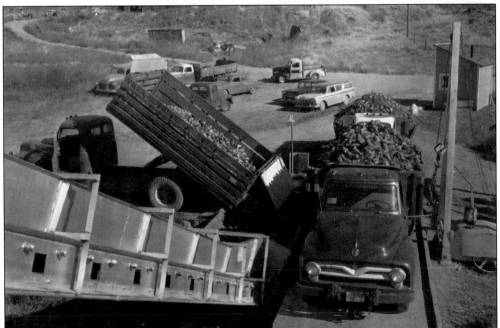

Oral had a beet dump, or a loading facility, for the sugar beet crop harvested by local farmers. The beets were shipped on the train to the U and I sugar beet processing plant at Belle Fourche. The plant closed in 1964, halting the production of sugar beets on the Angostura Irrigation Project.

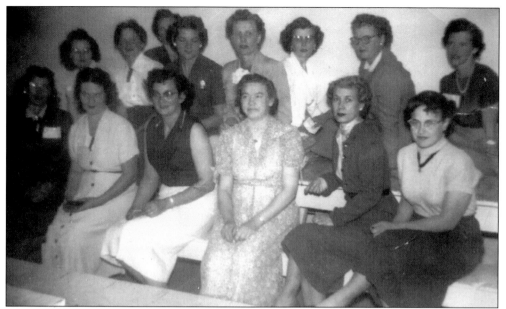

When the Angostura Irrigation Project was settled, new groups of neighbors were formed, such as these ladies. Pictured, from left to right, front to back, are: unidentified, Iris Knapp, Ad Stiver, LaRue Ainslie, Delores Klinker, unidentified, Lois Jorgenson, Viola Zolnowsky, Katherine Johnson, Vivian Funk, Ila Belle Brotherson, unidentified, Elvera Varvel, and Colleen Peck.

Extension clubs were for socializing and learning. The Project Pals was the club on the east side of Oral. Members pictured here are, from left to right, front to back: Gladys Writer, Leona Hageman, Vivian Funk, Arlene Wilhelm. Oleta Wyatt, Edith Gamet, Lena Rose Hussey, Francis McClung, Katherine Scott, Elvera Varvel, Joyce DeBoer, Flora Foster, and Ad Stiver.

Alfred Seder was the local weather prognosticator. He studied past weather patterns and had many of his own ideas on forecasting. He was nearly always right too. His wife, Ruth, was a quiet, hard working woman who even put Alfred in his place once when they were working cows together. She let him know that he could address her in a civil manner or he could work alone. His attitude improved.

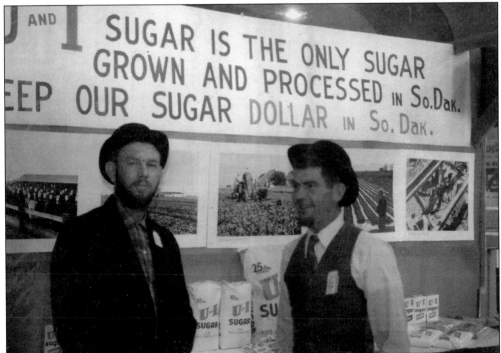

Delbert Writer was a fieldman for the U and I Sugar Company and he also owned and operated a farm. Vic Wilhelm was a farmer on the Angostura Irrigation Project. The booth pictured above was used to promote South Dakota products.

Peggy and Jerry Wyatt enjoyed life on the farm. Jerry appears to be contemplating the future of the world.